IMAGES
of America

EVANSTON

"Queen City of the Mountains" is a fitting description of Evanston, especially for travelers approaching from the east. After crossing Wyoming's high desert plateaus, they climb two mountain divides before descending into Evanston in the Bear River Valley, with the High Uintas visible to the south. (Courtesy of the Uinta County Museum.)

ON THE COVER: Evanston's identity as a railroad town is reflected in this portrait of the workers at the roundhouse around 1880. The roundhouse, built of native stone, was constructed in 1871 and used to service steam locomotives on the newly completed transcontinental railroad. (Courtesy of the Uinta County Museum.)

IMAGES
of America

EVANSTON

Barbara Allen Bogart and
the Uinta County Museum

ARCADIA
PUBLISHING

Published by Arcadia Publishing
Charleston SC, Chicago IL, Portsmouth NH, San Francisco CA

Printed in the United States of America

Library of Congress Control Number: 2009920008

For all general information contact Arcadia Publishing at:
Telephone 843-853-2070
Fax 843-853-0044
E-mail sales@arcadiapublishing.com
For customer service and orders:
Toll-Free 1-888-313-2665

Visit us on the Internet at www.arcadiapublishing.com

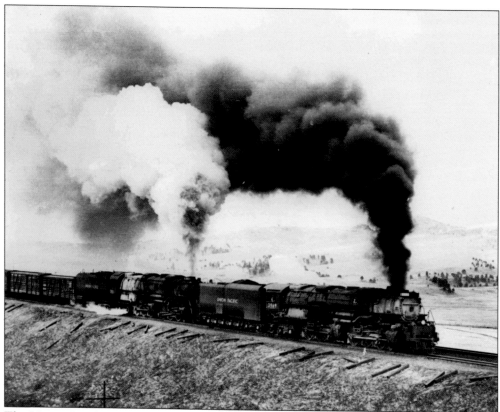

The Union Pacific Challenger locomotive No. 3969 steams through the Bear River Valley sometime between 1942 and 1961. The Challenger locomotives were built for the Union Pacific Railroad. Two of them are still in operation as part of the UP's historic fleet. (Courtesy of the Uinta County Museum.)

CONTENTS

ACKNOWLEDGMENTS

This book draws primarily from the historical photograph collection of the Uinta County Museum. Our greatest thanks are due to the dozens of photographers and collectors who created and preserved the images in our collection. Among them, Charles Guild deserves special mention for his dedication to preserving and copying Evanston's photographic record. Without that effort, many of the images that grace these pages would have been irretrievably lost.

We are also grateful for the assistance of Mary Hipol and Leslie Carlson at the Uinta County Library; Jane Law at the Evanston Urban Renewal Agency; John Waggener at the American Heritage Center, University of Wyoming; and Cindy Brown at the Wyoming State Archives for providing images from their photograph collections.

Many individuals gave us access to images in their own collections. They include Susan Barrett, Jane Beckwith, Edie Bell, Gary Cazin, Nadine Crompton, Rowdy Dean, Susan Hartzell DeGering, Geoff Dobson, Anna Lee Frolich, Bernard Green, Deb Griffin, Marilyn Harris, Walter Jones, Helen Morrison, Karma Osborn, Sandy Ottley, Connie Trout Owen, Jon Pentz, Claudia Proffit, Paul Skyles, Flora Wagstaff, and Wayman Wing.

Thanks, too, to museum volunteers who read and commented on drafts of the book—Joyce Arendsee, Donna Butcher, and Dan Bogart. And thanks to Jim Davis and Shelly Horne, who answered numerous historical questions with their characteristic good humor. Special recognition goes to museum curator Kay Rossiter, who kept track of all the images during the selection and preparation process for this book.

Although every effort has been made to ensure historical accuracy and to recognize everyone who helped put this book together, we apologize for any errors or omissions that appear. Unless otherwise noted, all images are from the collections of the Uinta County Museum. Other sources are identified with the following abbreviations:

EURA: Evanston Urban Renewal Agency
UCL: Uinta County Library
WSA: Wyoming State Archives

INTRODUCTION

Evanston, Wyoming, the seat of Uinta County, is nestled in the Bear River Valley of southwestern Wyoming just a few miles from the Utah border. The Uinta Mountains are 30 miles to the south. Medicine Butte, a local landmark, raises its majestic head just to the east.

Although the town of Evanston was not established until 1868, the area had a long and rich human history before then. Beginning in the 16th century, Evanston's corner of southwestern Wyoming was part of New Spain. In 1820, it became one of Mexico's outlying possessions. After the war with Mexico in 1848, it became part of Utah Territory. When Wyoming Territory was separated from Dakota Territory in 1868, the northeastern corner of Utah Territory was carved off to become the new southwestern corner of Wyoming—making Wyoming a perfect rectangle.

The Bear River Valley and the surrounding region were part of the Eastern Shoshones' territory for several centuries before the Fort Bridger Treaty of 1868 established the Wind River Reservation as their designated home. Through the rest of the 19th and into the 20th century, however, Shoshones continued to travel through the area, as the stories of local ranch families attest.

From the 1820s through the 1840s, trappers engaged in the Rocky Mountain fur trade traveled through and camped in the Bear River Valley and the adjacent mountains. The first mountain man rendezvous was held some 50 miles southeast of Evanston on the Henry's Fork River in 1825. In 1843, mountain man Jim Bridger established a trading post about 30 miles east of present-day Evanston, along the Oregon Trail. Fort Bridger, as the post came to be known, attracted a few permanent white settlers to the area, but full-scale settlement of southwestern Wyoming did not come until the tracks of the Union Pacific Railroad reached here in the fall of 1868. Evanston, like the other towns along the UP route through southern Wyoming, owes its existence to the railroad.

This book uses photographic images to tell some of the key stories from Evanston's past, from its beginnings as an end-of-the-tracks shanty town to its present status as a community with great pride in its history. Chapter one, titled "Rails, Rigs, Ranches, River," deals with the early economic foundations of the community. Here are images depicting the impact of the railroad on the community, the role that coal mining and early oil exploration played in the area, the significance of ranching as a part of community life, and the presence of the river in shaping the town.

Chapter two, "Queen City of the Mountains," focuses on the built environment of downtown Evanston, the heart of the community where a remarkable number of historic structures dating from the 19th and early 20th centuries are still standing. In this chapter, there are the stories of the private enterprises and public institutions that created the familiar landscape of buildings we live in today.

Chapter three, "All around the Town," begins with stories of people whose lives and work had an early impact on the community. It continues with stories of how we have entertained ourselves over the years, of school classes and athletic teams, and of our love of outdoor activities.

In chapter four, "The World Comes to Evanston," we explore the ways in which our history and the history of the nation and the world have been intertwined through the years. Here are the stories of soldiers, of travelers, and of boom-and-bust jolts to the local economy from national and international forces.

Finally, chapter five, "Pride and Preservation," recounts how the effects of the energy boom of the 1980s gave impetus to historic preservation efforts in Evanston.

The images in this book do not tell the whole story of Evanston's history. Instead, they provide intriguing glimpses into the community's past. They remind us that the lives of Evanston's residents have been shaped by the place and that the past and the present exist together in our experiences of the landscape that we share.

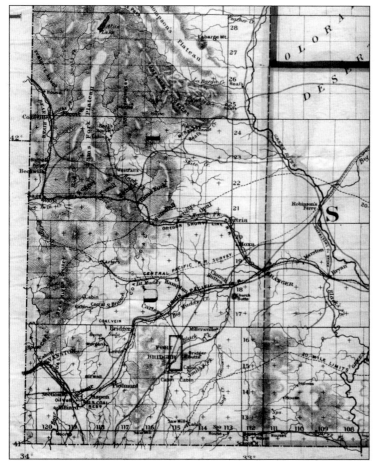

Holt's map of the Territory of Wyoming, published in 1885, shows Evanston in its setting in southwestern Wyoming. Smaller communities along the tracks of the Union Pacific are shown, along with the location of coal deposits and topographical features.

One

RAILS, RIGS, RANCHES, RIVER

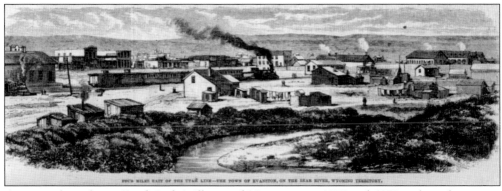

FOUR MILES EAST OF THE UTAH LINE—THE TOWN OF EVANSTON, ON THE BEAR RIVER, WYOMING TERRITORY.

A series of articles in *Frank Leslie's Illustrated Newspaper* in 1877 and 1878 took readers on an armchair tour across the continent on the Union Pacific Railroad. The buildings that appear behind the train are on Front Street, Evanston's first commercial district. Evanston's Chinatown is located between the tracks and the Bear River.

Union Pacific chief engineer Grenville Dodge platted the town of Evanston in 1869 and named it after his friend, railroad surveyor James Evans. Ironically, Evans had surveyed the railroad route in eastern Wyoming but may never have visited Evanston on the western side.

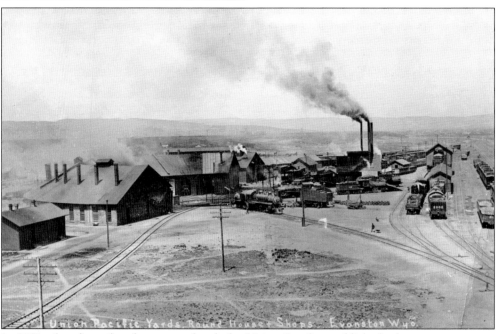

In 1869, after the railroad was completed, the Union Pacific established a locomotive service facility at Wahsatch, about a dozen miles west of Evanston. But within a few months, the site proved unsuitable. It was too high, dry, and windy. So the company moved the facility to Evanston, where there was more shelter from the elements and plenty of water from the Bear River.

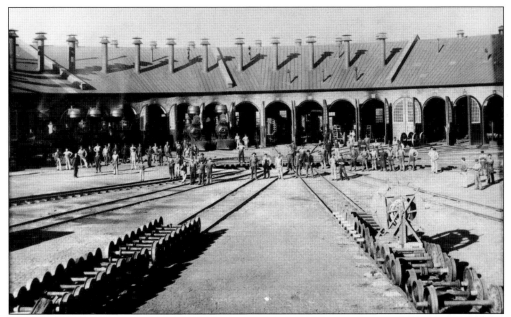

This 20-stall stone roundhouse was built in 1871, three blocks northwest of the center of town. Locomotives were moved from the main track to one leading to the hand-operated turntable. The turntable was rotated to point an engine into the stall where it was to be serviced. After the work was completed, it was backed out onto the turntable and aimed back toward the main track. (Courtesy of EURA.)

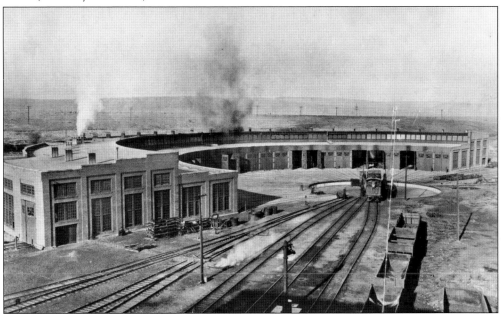

By the early 1910s, the newer, more powerful steam locomotives used by the Union Pacific became too large to fit into the stone roundhouse. So in 1912, the company built the present 28-stall structure of brick several hundred yards north of the stone roundhouse. Two other brick buildings, the machine shop and the powerhouse (not pictured here), were built in 1913. (Courtesy of Union Pacific Museum.)

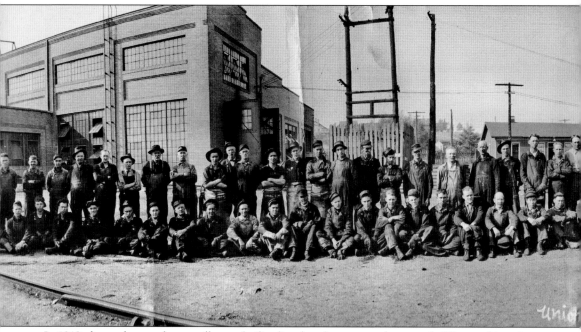

In 1919, the workers at the roundhouse facility lined up for a group photograph. The machine shop is on the left; the roundhouse is on the right. From the beginning of the town's existence, the

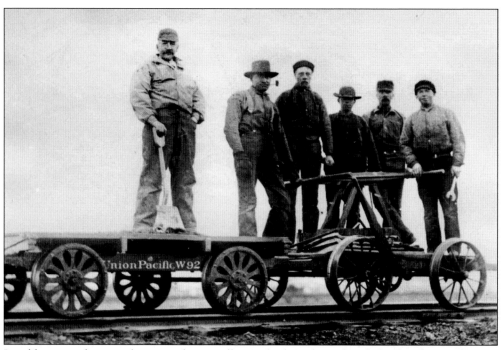

In addition to their employees at the roundhouse facility, the railroad also hired section crews to maintain 6-mile sections of the track. A section crew consisted of a foreman and 4 to 10 crew members. They lived in section camps set up at the midpoints of their 6-mile stretches. Section camps also often served as watering stations for locomotives. (Courtesy of Karma Osborn.)

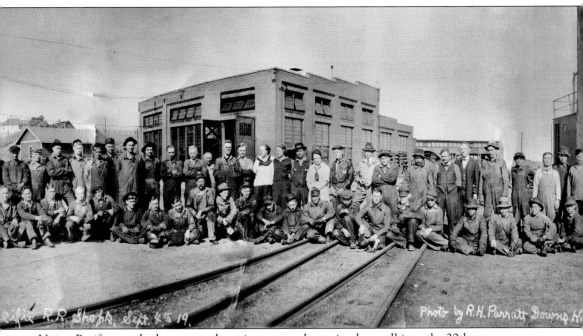

Union Pacific was the largest employer in town and remained so well into the 20th century.

In the early 20th century, the railroad used specially adapted automobiles to transport maintenance crews and inspectors along the tracks. (Photograph by J. E. Stimson; courtesy of WSA.)

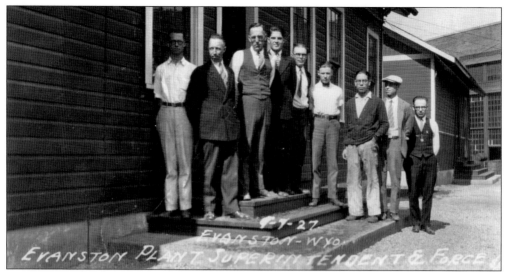

In 1926, the Union Pacific shut down the Evanston roundhouse facility—a devastating move for the community since nearly a quarter of the town's population depended on the workers' income. But a year later, after a delegation of public officials and citizens met with company representatives, the facility was reopened as the Evanston Reclamation, Repair, and Manufacturing Plant. Known officially as the Reclamation Plant and informally as "the shops," the facility was charged with salvaging, repairing, and manufacturing hundreds of items used throughout the Union Pacific system. Here the plant superintendent and plant foremen pose in front of the superintendent's office building. (Courtesy of EURA.)

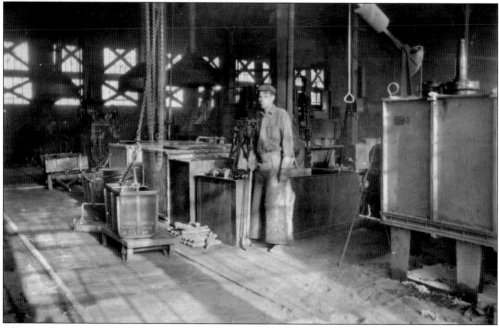

The Reclamation Plant's annual report for 1929 featured photographs of workers in various departments, including the blacksmith, tin, and sheet metal shops. According to Elmer Danks, who worked at the shops from 1929 until they closed in 1971, "All the men who worked at the shops were highly skilled workers."

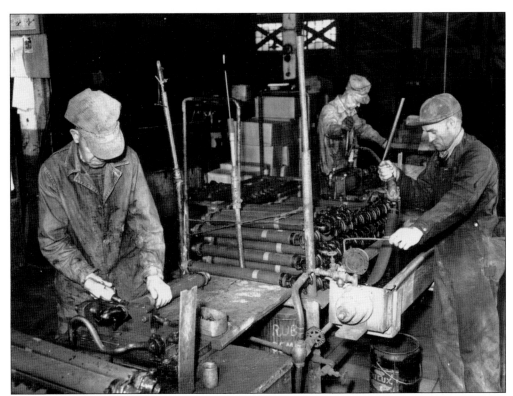

Employment at the Reclamation Plant peaked during World War II at over 300. After the war, the Union Pacific began the transition from steam to electric-diesel power in its locomotives, which reduced the number of parts that needed to be manufactured or repaired. Employment at the Reclamation Plant began to drop in the late 1940s and early 1950s, although, as these photographs from 1965 show, it was still a busy facility then. The Reclamation Plant was finally closed in December 1971, and the buildings were donated to the City of Evanston in 1972.

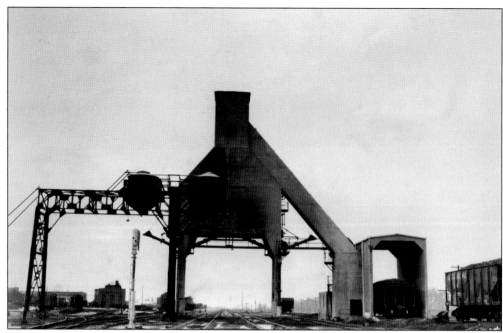

Evanston was a coaling stop for steam locomotives on the Union Pacific line. The coal station stood on the southeastern edge of the roundhouse facility. (Courtesy of UCL.)

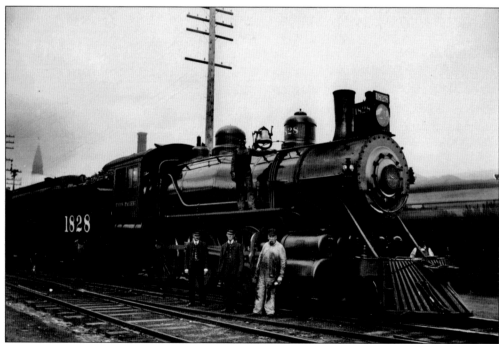

The railroad also employed many Evanston residents as crew members on passenger and freight trains. Here "Dad" Linley, Johnny Code, and Tom Richards, along with two unidentified men, pose with Vauclain compound passenger locomotive No. 1828 sometime between 1902 and 1904.

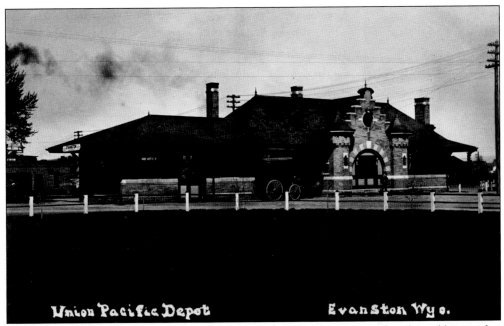

The brick passenger depot, built in 1900 at the end of Tenth Street, replaced an older wooden structure to the north. It featured separate waiting rooms for men and women along with a baggage room. The railroad telegrapher was also housed in the depot. (Courtesy of Rowdy Dean.)

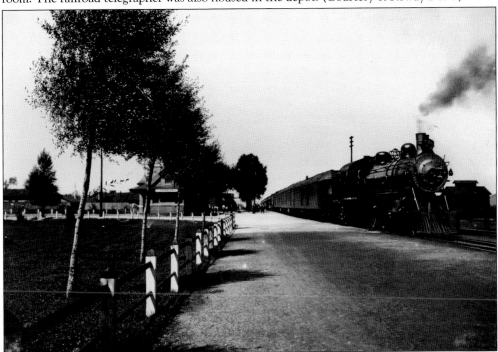

Evanston's passenger depot was a busy place. Troop trains passed through here during World War I and World War II. Local residents traveled to Salt Lake City and Ogden in Utah. Local students attending the University of Wyoming in Laramie regularly took the train back and forth between there and Evanston. (Photograph by J. E. Stimson; courtesy of WSA.)

For some Evanston residents, apparently, train watching was a leisure activity. Beyond the train platform is the Pacific Hotel—originally known as the Mountain Trout Hotel, mentioned favorably for its cuisine and Chinese waiters in the 1877 *Frank Leslie's Illustrated Newspaper* article. The hotel was partially burned in the 1890s and then used as Union Pacific offices before being demolished a few years later. (Courtesy of UCL.)

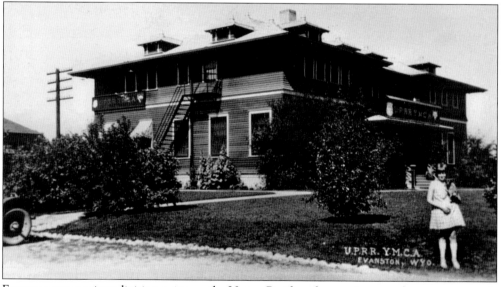

Evanston was a minor division point on the Union Pacific, where train crew changes were made between Green River, Wyoming, (80 miles east) and Ogden, Utah (80 miles west). The Union Pacific built this YMCA on Front Street just southeast of the roundhouse complex for use by train crews. The building was also called the UP Clubhouse.

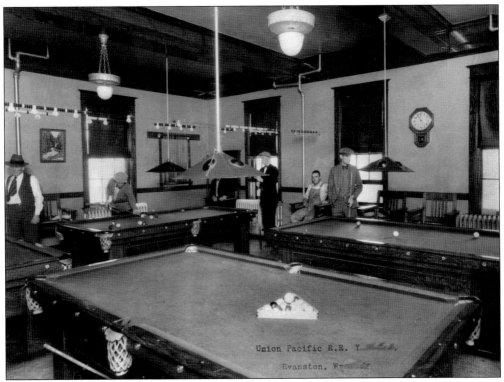

The YMCA was intended for the use of train crew members, where they could rent a room, get a meal, take a shower, or spend layover time in leisure activities. (Both, courtesy of the Thomas E. Whittaker family.)

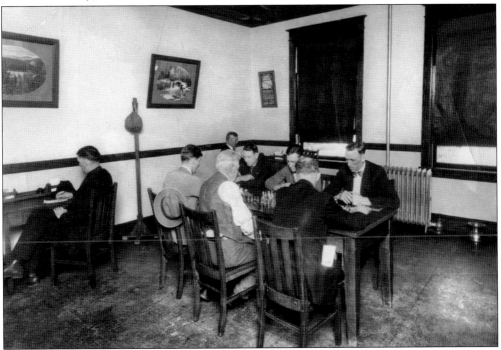

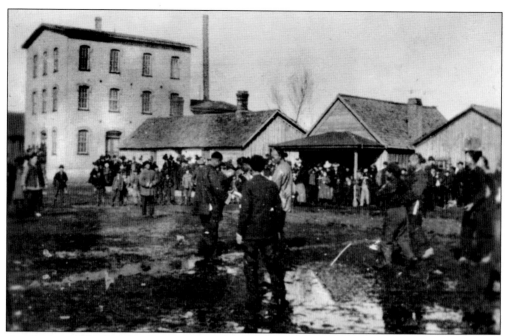

A unique neighborhood in Evanston was Chinatown. Beginning in 1869, after the tracks were completed, the Union Pacific Railroad hired Chinese laborers on section crews and in the coal mines at Almy, about 6 miles north of town. Chinatown flourished from the early 1870s until the 1910s. The peak population of Chinese in Evanston was 100 in the early 1880s.

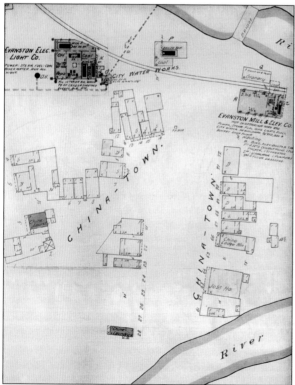

Chinatown was situated on the northeast side of the tracks on property that was owned by the Union Pacific. This Sanborn insurance map from 1898 shows a mix of Union Pacific section houses along with Chinese-built structures within Chinatown. The tracks and the passenger depot are off the map to the left.

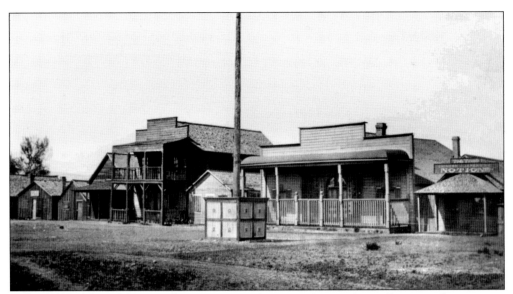

The two dominant structures in Chinatown, built by the Chinese themselves, were the two-story "China Lodge" (on the left) and the temple or joss house (in the center). The lodge functioned as the headquarters for the Tung Sen Tong, the local Chinese benevolent association, and as the social and recreational center for the Chinese community. Judging from archaeological evidence, recreational activities included gambling and opium use. White residents of town called it the "opium den." The small store on the right sold Asian imported goods. Some Evanston families still own items purchased in Chinatown.

The joss house was built in 1874, one of dozens of temples built by Chinese immigrants in the western United States in the 19th century. It served as both a place of worship and a hostel for Chinese visitors traveling on the railroad. The building burned to the ground in January 1922. Just before the fire, Evanston residents salvaged items from it, including the two 10-foot-tall carved wooden panels that graced either side of the front door. The panels are now displayed in the Chinese Joss House Museum, a replica of the original temple, in Evanston's Depot Square.

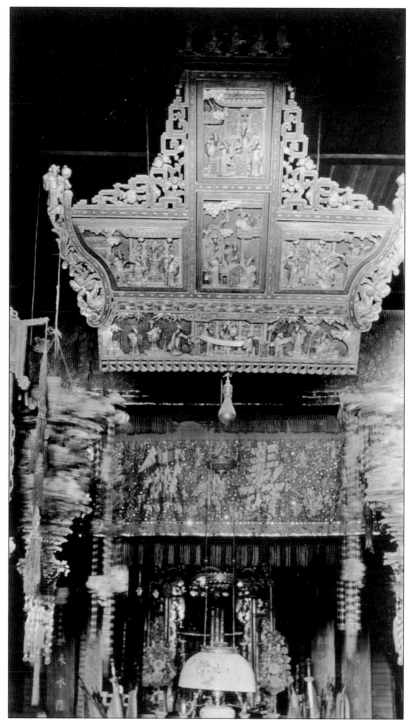

The only known photograph of the temple interior shows an elaborately carved and decorated altar. In the 1950s, Evanston resident Delmar Dean recorded his memories of ducking into the temple as a child and being awed by the embroidered silk hangings and polished brass objects. (Courtesy of the Beckwith family.)

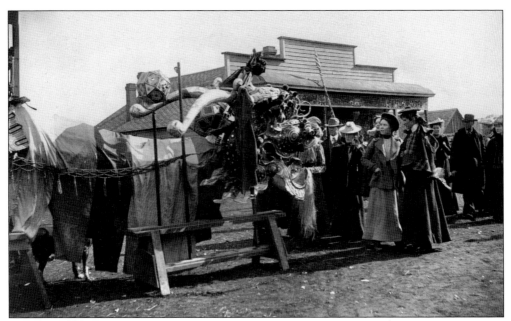

The big event of the year in Chinatown was the 10-day-long celebration of the New Year. Calculated according to the lunar calendar, it fell between the end of January and the end of February in any given year. "China Big Day" marked the end of the New Year Festival. Many white residents from town came to Chinatown for the day, and children were released from school to watch the colorful events. (Courtesy of the Beckwith family.)

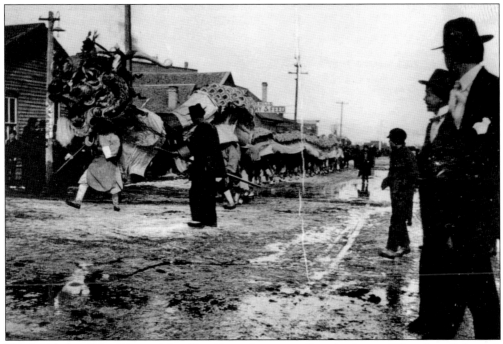

The highlight of the Chinese New Year Festival was parading the dragon "Gum Lung" through the streets of downtown. The parade dragon may have been jointly purchased with or rented from another Chinese community, such as the one in Rock Springs, 100 miles to the east.

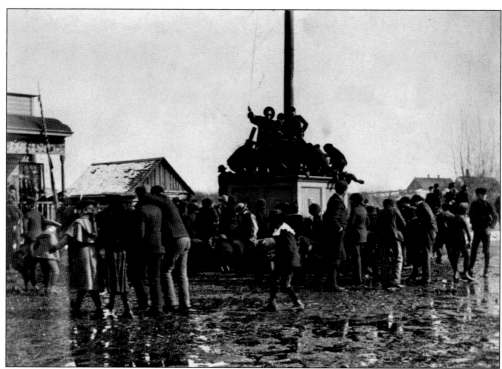

The New Year celebration culminated with shooting a rocket carrying a wooden ball into the air. The ball contained the key to the temple. Whoever recovered the ball and key became the manager of the temple for the coming year. In some years, according to newspaper accounts, the scuffle for possession of the key became quite rough. (Courtesy of American Heritage Center, University of Wyoming.)

In addition to jobs as coal miners or railroad workers, the Chinese also worked in hotels, restaurants, and stores. Others operated their own businesses, including the visibly proud owner of this laundry in Chinatown. (Courtesy of the Beckwith family.)

Several Chinese turned to truck gardening to make a living—not an easy proposition at 6,700 feet above sea level. Using irrigation techniques adapted from their homeland, they raised and sold vegetables to grocers, restaurants, and homemakers all over town. Lock Long Choong was one such gardener. He called himself Mormon Charlie—perhaps to win favor from his customers. A favorite local story about Mormon Charlie concerns his practice of giving small children rides in his empty baskets at the end of his daily rounds. He died in 1939 and is buried in the city cemetery.

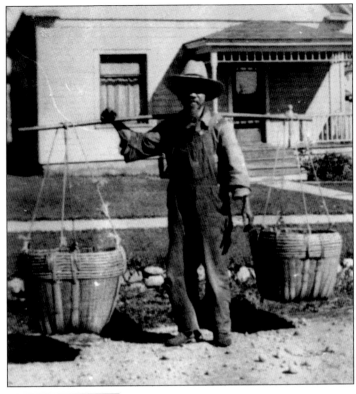

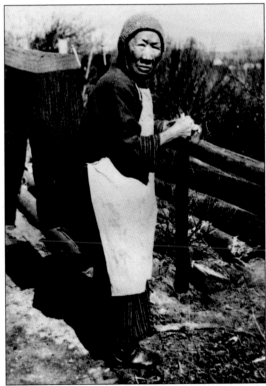

One of the very few Chinese women in Evanston was Ah Yuen, known locally as China Mary. Her origins are obscure, but she seems to have come to Evanston in the early 1900s when she was in her 40s. In her later years, she lived alone in a small house north of Chinatown, where reportedly she stored bonded whiskey for a local saloon keeper during Prohibition. Tourists who wished to take her picture were charged a dime for the privilege. She used the dimes to pay children to bring her fish from the Bear River or run errands. She died in 1939 and is buried in the city cemetery.

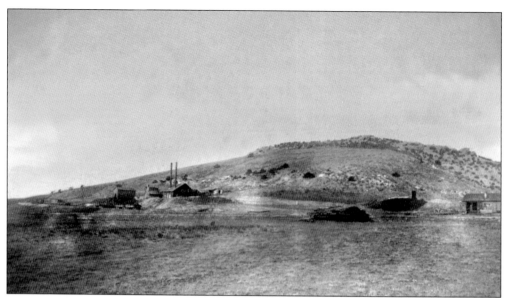

Coal lay beneath much of the route of the Union Pacific Railroad through southern Wyoming. Between 1867 and the 1880s, more than a dozen coal mines were developed along a ridge east of the Bear River a few miles north of Evanston. The community of Almy grew up around the mines. Shown here is one of the larger mines at Almy in 1871. (Photograph by William Henry Jackson; courtesy of U.S. Geological Survey.)

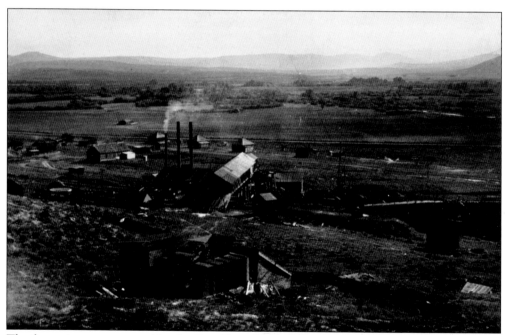

The first mines were opened by the Bear River Coal Company in 1867, followed by the Rocky Mountain Coal Company and several other operators. By 1874, the Union Pacific Coal Company had gained control of almost all the mines—and the coal—in Almy. Shown here is Mine No. 3 at the south end of the ridge.

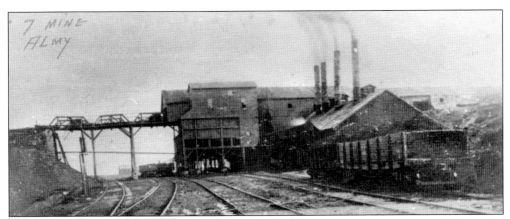

A spur line from the main UP track ran north of Evanston to transport coal from the Almy mines.

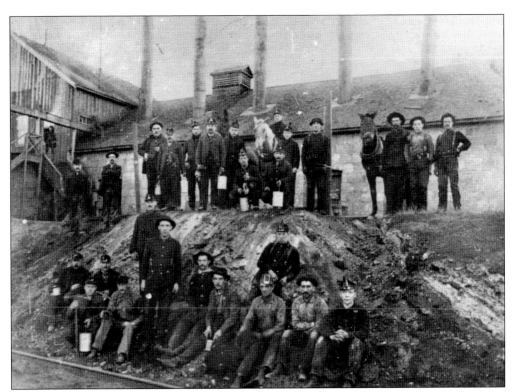

Many coal miners at Almy were recruited by the Union Pacific Coal Company from England and Wales because they had experience as miners. Others came from countries in northern Europe, including a number of Finns.

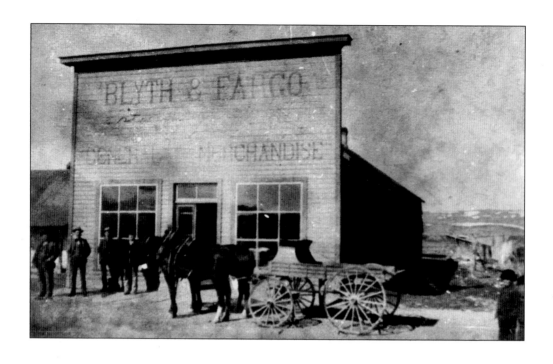

Two of the large general merchandise businesses from Evanston established branch operations in Almy to serve the miners and their families. The Rocky Mountain Mercantile was operated by the Beeman and Cashin Company. (Below, courtesy of UCL.)

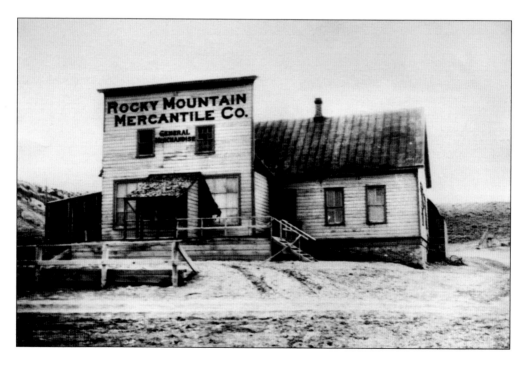

Crompton's View in Almy was built by miner and homesteader William Crompton in 1886. Miners at Almy often took up land under the Homestead Act of 1862 and established ranches. The families lived and worked on the homesteads while the men worked in the mines. While many of these ranches were in the vicinity of Almy, others were located as much as 15 miles southeast of Evanston. Men worked in the mines during the week and then walked or rode the train to and from their homesteads. (Courtesy of Nadine Crompton.)

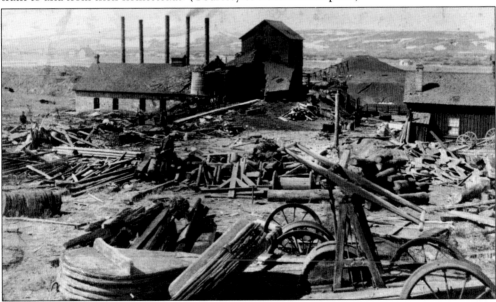

This photograph of the 1895 explosion at Almy Mine No. 8, toward the north end of the ridge, is vivid proof that the mines in Almy were dangerous. A series of fatal explosions killed dozens of miners in 1881 and 1886. The 1895 explosion killed 59 miners—at the time, the worst mining disaster in Wyoming's history. By 1901, all the mines in Almy had been closed. But in the winter, along the Almy ridge, steam that rises from the snow is evidence that underground fires still smolder today.

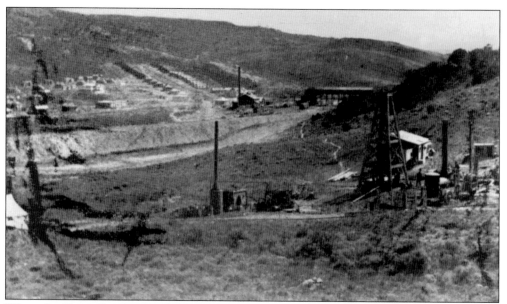

When the Union Pacific closed the mines at Almy, they moved some of the miners to a small mining camp southeast of Evanston called Spring Valley, shown here. In 1902, the company hired L. E. Nebergall to drill a water well for the camp. But what came up out of the ground was oil. In this photograph, the mining operation and camp housing can be seen in the distance, with the drilling rig that was to eclipse them in the foreground. (Courtesy of Walter Jones.)

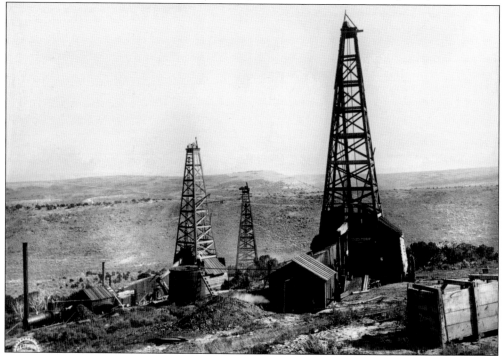

Although the Union Pacific tried to squelch news of the oil discovery, the word spread quickly. By 1904, more than 35 companies had staked claims in the Spring Valley field and a genuine boom was on. (Photograph by J. E. Stimson; courtesy of WSA.)

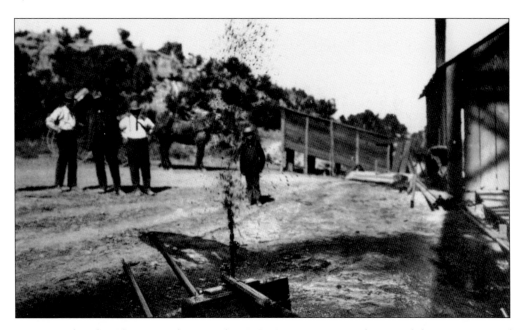

Pictures taken by Cheyenne photographer J. E. Stimson captured some of the excitement of discovering oil and documented the process of pumping it. (Photographs by J. E. Stimson; courtesy of WSA.)

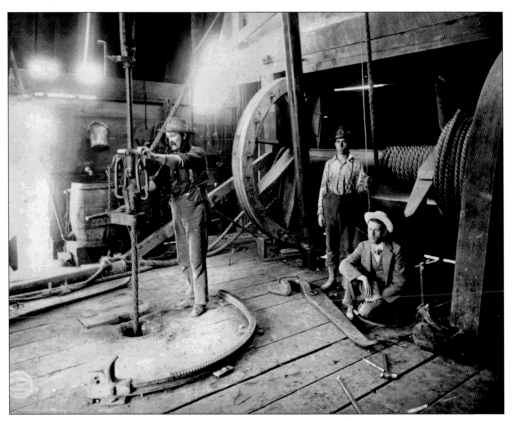

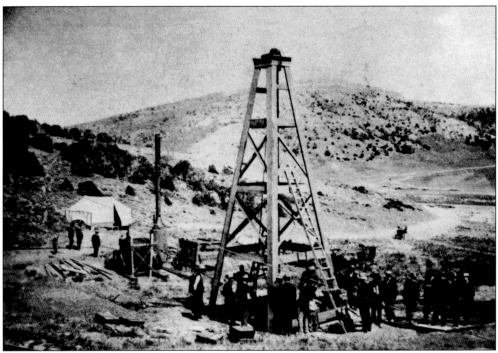

It seems that everyone wanted to get a piece of the Spring Valley oil action in the first decade of the 20th century. Local producers were joined by companies like Atlantic and Pacific Oil Company based in San Francisco, the Jager Oil Company of Chicago, and other companies from Kansas and Michigan. (Courtesy of UCL.)

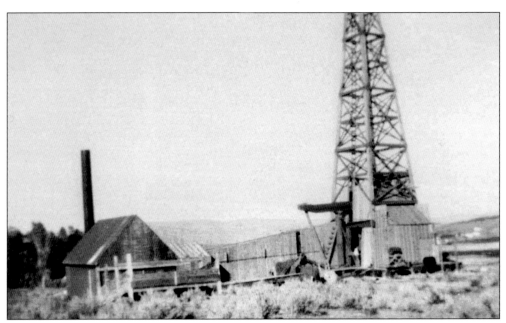

Local entrepreneurs also contracted oil fever. Shown here is a well belonging to Isidore Kastor, who owned a men's clothing store on Front Street. (Courtesy of Gary Cazin.)

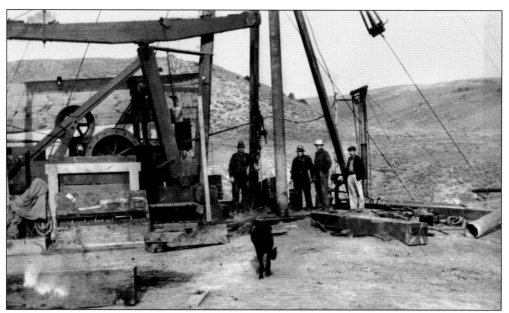

The Spring Valley wells were relatively shallow, and by 1920, most of them were exhausted. Without the technology needed to drill deep wells, the boom quickly went bust. Nevertheless, a few local producers continued to pump oil.

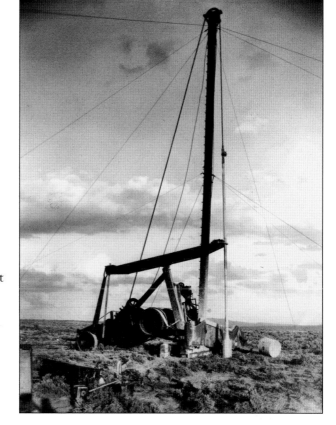

In 1912, oilman Arthur J. Whiteman arrived in Spring Valley from Pennsylvania. As producers began pulling out of the Spring Valley field, he bought up their wells. He eventually bought a small local refinery, moved it to the Spring Valley field, and produced gasoline and other products for local consumption into the 1950s. Some half a dozen wells in Spring Valley are still producing small amounts of oil today.

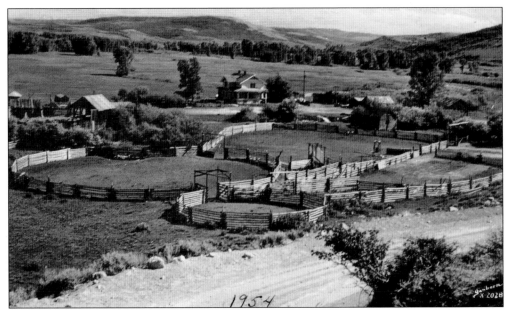

Ranching has been an integral part of the community's economic and social life from the beginning. The railroad, of course, provided access to markets, which made ranching economically feasible. The Guild ranch, shown here in 1954, was established in 1869 at Piedmont, about 20 miles east of Evanston on the original Union Pacific line. The ranch is still operated by members of the Guild family.

The first ranch in Uinta County was established by John Walker Myers in 1857, a good decade before the railroad arrived. The first Myers ranch was located where the Mormon Trail crossed the Bear River southeast of present-day Evanston. John's son, George, established his ranch (shown here in the 1940s) east of the original Myers ranch, near Piedmont. (Courtesy of Marilyn Harris and the Lewis Myers family.)

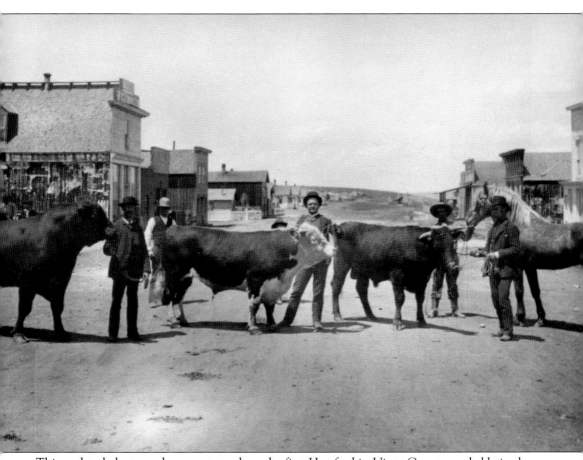

This undated photograph purports to show the first Hereford in Uinta County, probably in the mid- to late 1880s. Herefords remained local ranchers' favorites through the 1940s, when Angus cattle gained in popularity. (Courtesy of Sandy Ottley.)

Cattle ranchers raised hay to feed their stock through the winter months. Here hay is mowed on the Ryan Ranch in 1903. (Photograph by J. E. Stimson; courtesy of WSA.)

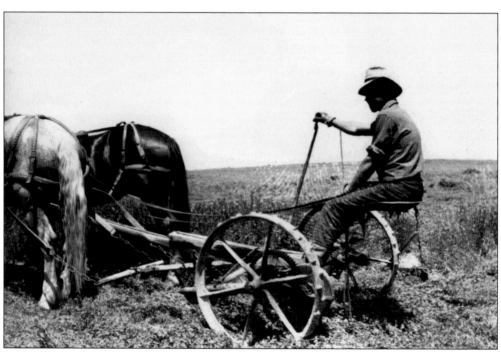

Lewis Myers rides a hay rake on the George Myers ranch near Piedmont in the 1940s. (Courtesy of Marilyn Harris and the Lewis Myers family.)

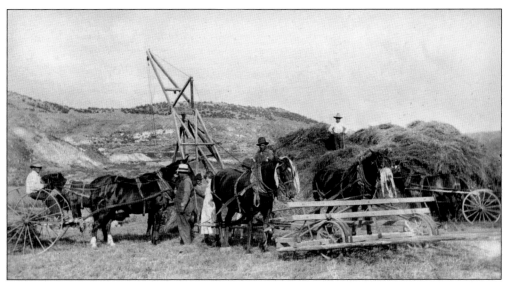

From left to right, Abe Salmela, Oscar Huhtala, Eino Salmela, Hihla Salmela, Bill Salmela, unidentified, and Oscar Poorainer (on haystack) are haying on the Salmela ranch in Almy. The Salmela brothers were coal miners as well as ranchers.

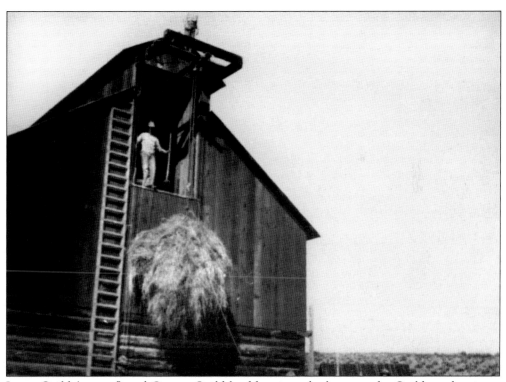

James Guild (on roof) and George Guild load hay into the barn on the Guild ranch using a Louden fork.

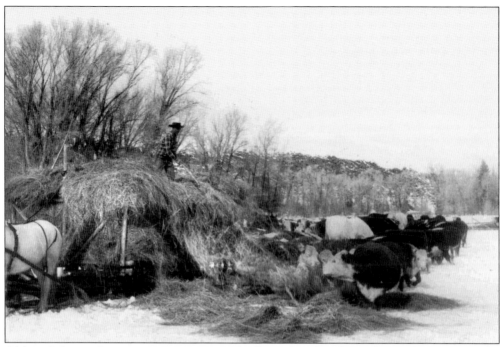

Although horse-drawn equipment was gradually replaced with mechanized tractors in the 1950s, many ranchers like Glenn Saxton continued to use horse power to haul sleighs for winter feeding.

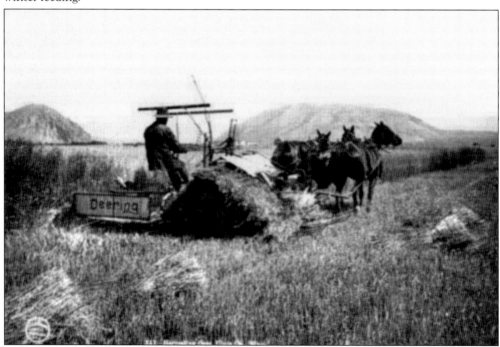

In the first part of the 20th century, ranchers also raised grain—mostly barley and oats—for ranch consumption. This unidentified Uinta County rancher is harvesting oats in 1903. (Photograph by J. E. Stimson; courtesy of WSA.)

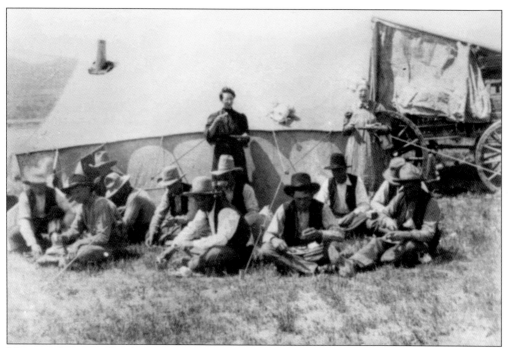

Most ranches were family operations, with extra hands hired on for special tasks such as haying and roundups in the spring and fall. Here the cowboys on the Neponset Land and Live Stock Ranch north of Evanston enjoy a noon meal during roundup.

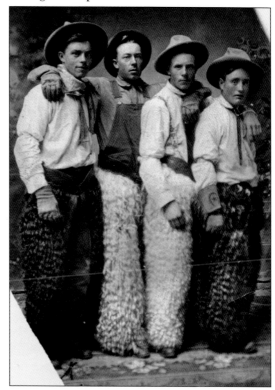

Cowboys from the Crown Ranch in the Hilliard neighborhood south of Evanston pose for a formal portrait in their best chaps. From left to right are William Wagstaff, Jess Clark, Joseph Gilmore, and James Gilmore. (Courtesy of Flora Wagstaff.)

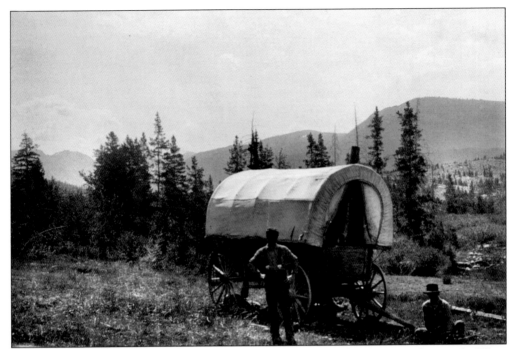

Although historically there was tension between cattle ranchers and sheep ranchers in the West, many ranchers in southwestern Wyoming raised both sheep and cattle. Here herders pose with their sheep wagon on the summer range in the Uinta Mountains south of Evanston.

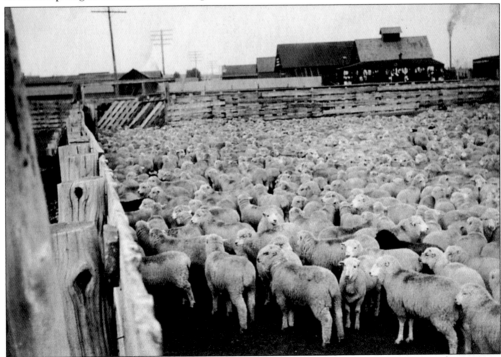

Sheep belonging to the Neponset Land and Live Stock Company are herded into a corral. (Courtesy of Anna Lee Frolich.)

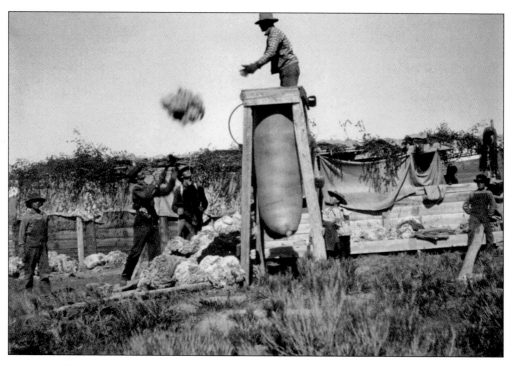

A crew works at bagging fresh fleeces. The man on top of the wooden frame catches the tossed fleeces and then stuffs them into the suspended sack.

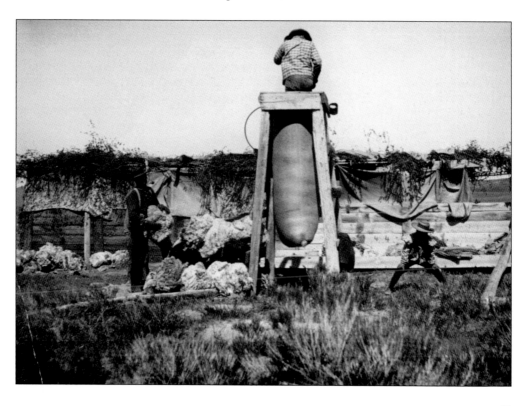

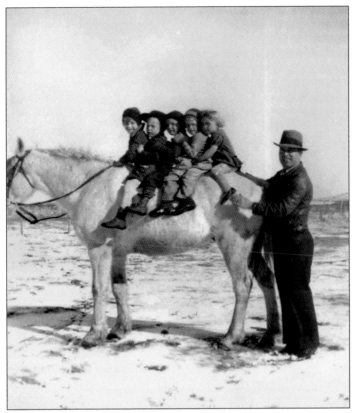

Ranch children are put to work early on the ranch, but they also have perks that town kids might not enjoy. These five children on horseback were photographed in 1938. From front to back, they are Lamoyne Ashton, Paul Ashton, Elmo Matthews, Wayne Turner, and Karen Matthews, overseen by their grandfather Victor Matthews. (Courtesy of the Proffit family.)

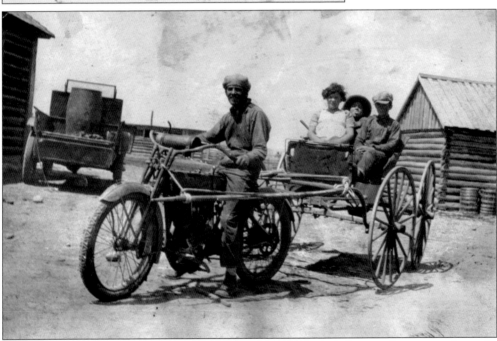

Improvisation is a big part of ranch life. Here Allie Burton has hitched a buggy to his motorcycle to take Alberta Wagstaff, David Wagstaff, and Heber Clark for a spin. (Courtesy of Flora Wagstaff.)

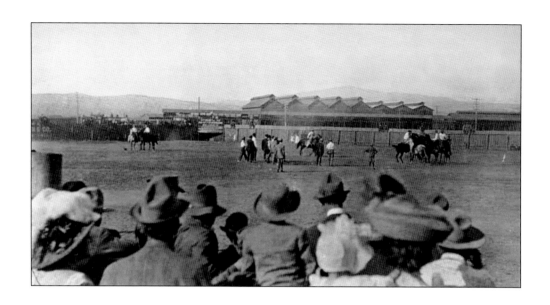

Visitors to the Uinta County Fair in the 1910s were treated to a demonstration of bronco riding in the fairgrounds arena. Not a full-fledged rodeo, the demonstration would have featured local cowboys showing off their skills. In the background are the Pacific Fruit Express icehouses. (Both, courtesy of Anna Lee Frolich.)

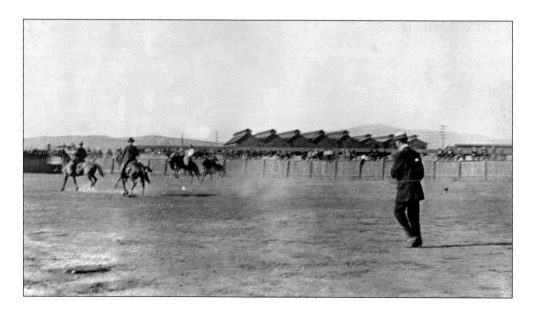

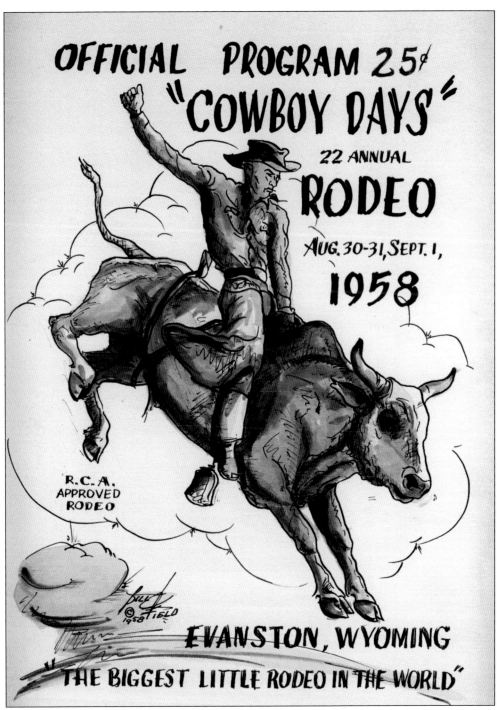

In 1936, a group of businessmen established Evanston's Cowboy Days, a three-day professional rodeo held during the Labor Day weekend. Cowboy Days was intended both as a tribute to ranching in the area and as a tourist draw. For years, Cowboy Days was billed as the "Biggest Little Rodeo in the World" (or "the West"). It featured regional talent as well as local riders. This drawing for the 1958 program cover was done by local artist Bill Fields.

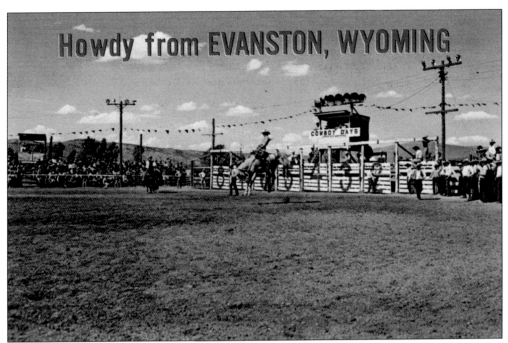

The Cowboy Days rodeo was held at the fairgrounds arena. By the early 1950s, when leisure travel by automobile was becoming increasingly popular, it attracted large crowds of visitors from out of town, especially from the Salt Lake City area. (Courtesy of Susan Barrett.)

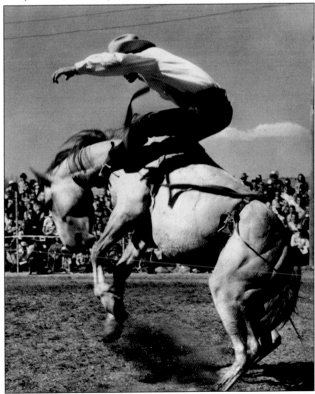

Local saddle horse Lightfoot, owned by Bud Fearn, became a bucking bronco for Cowboy Days in 1957.

45

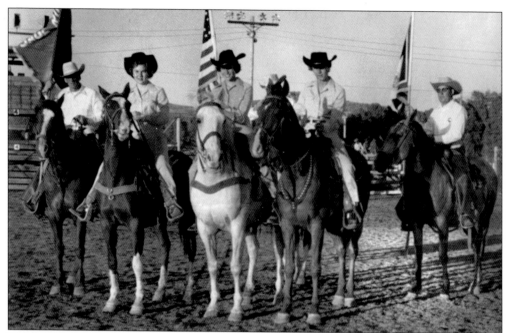

The Cowboy Days festivities have always included a queen and her attendants. The Cowboy Days court in 1958 included Madeline Anderson (left), Joye Brown as queen, and Mary Ann Mills (right). They are flanked by Verdon Moore on the left and Clarence "Sonny" Bateman on the right, representing the Sage Riders Posse.

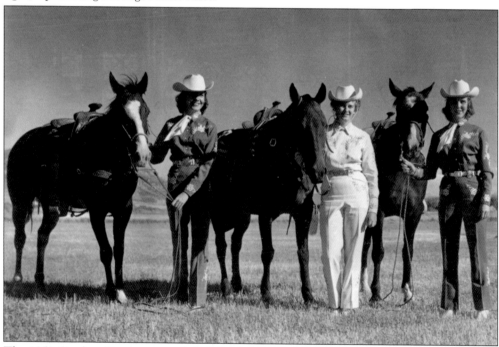

The 1959 Cowboy Days court included Queen Sherri Fearn (center) and attendants LaDene Powers (left) and Claudia Hamilton (right). Contestants for Cowboy Days royalty must demonstrate strong horsemanship skills.

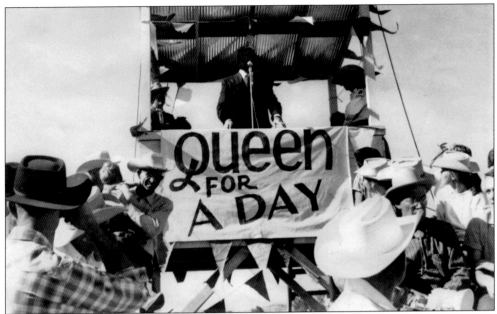

In 1959, Cowboy Days entertained a special guest—Wyoma Wright, winner of the television contest "Queen for a Day." She was treated to a surrey ride in the Cowboy Days parade and a night's lodging at Mirror Lake Lodge in the Uinta Mountains. In honor of the occasion, Al Pyatt's young dance group, the '49ers, performed for her on Main Street and on a special stage adjacent to the rodeo grounds.

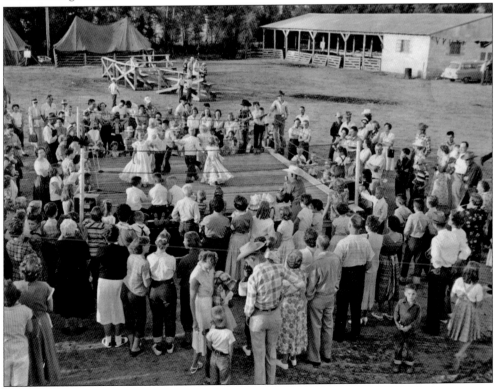

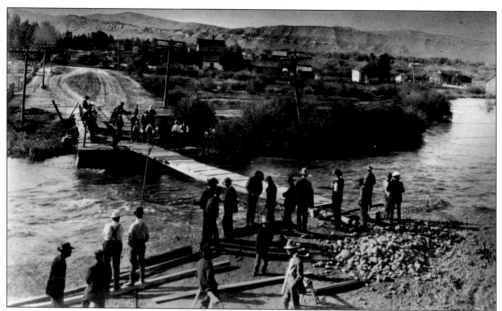

Maintaining a usable bridge over the Bear River was a high priority for Evanston residents because the river lay between the town and the coal mines at Almy. In the 1880s and 1890s, town council meeting minutes are full of references to construction and repair of the Bear River Bridge on County Road, which ran northeast from Ninth Street. In June 1906, the bridge was washed away by high spring runoff. This photograph shows the emergency measures being taken to restore the bridge. According to town council minutes, the Union Pacific Railroad assisted in the rebuilding effort. (Courtesy of WSA.)

When the river was low from mid-summer through the fall, travelers could cross the river either by bridge or by ford. (Courtesy of Anna Lee Frolich.)

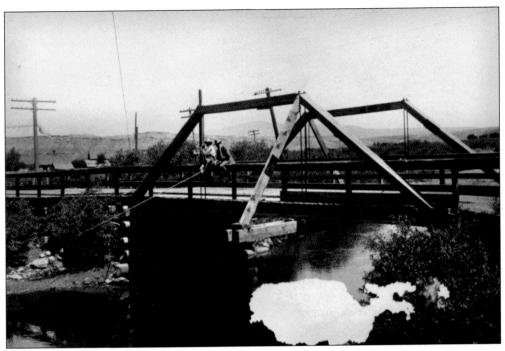

The bridge served recreational as well as transportation purposes.

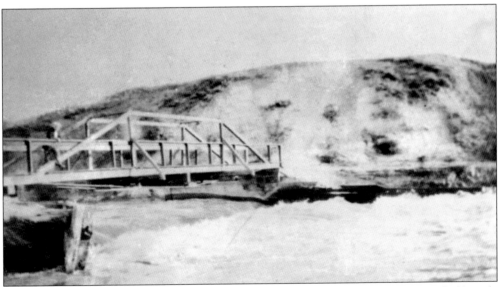

In 1929, a second bridge made of steel was constructed over the Bear River, less than half a mile upstream from the County Road bridge. Known as Red Bridge, it was built by the state highway department to carry traffic along the Lincoln Highway/U.S. 30. Just below the bridge, a deep hole formed that became a favorite swimming and skinny-dipping spot for teenagers.

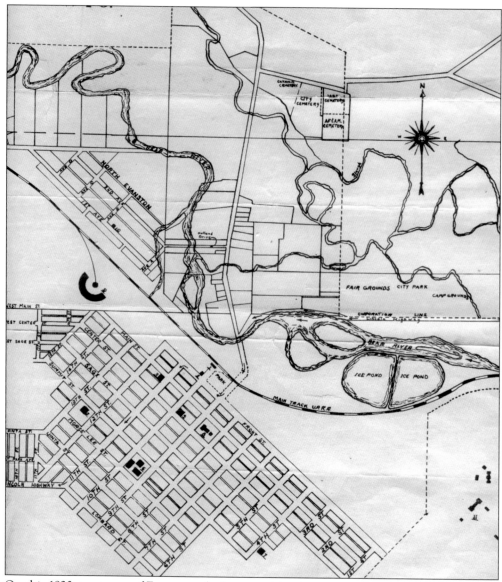

On this 1920 street map of Evanston, the large semicircular structure on the left represents the roundhouse. Above the river on the right are the Lincoln Highway and the city campground where travelers could stay the night. In the upper left is the neighborhood known as North Evanston. Evanston's original street grid has a quirky feature: When Evanston was platted in 1869, its main streets were laid out parallel with the railroad tracks rather than lined up with the compass points. This makes it difficult to give accurate directions. For some residents, east is synonymous with north, and west is the same as south!

Two

QUEEN CITY
OF THE MOUNTAINS

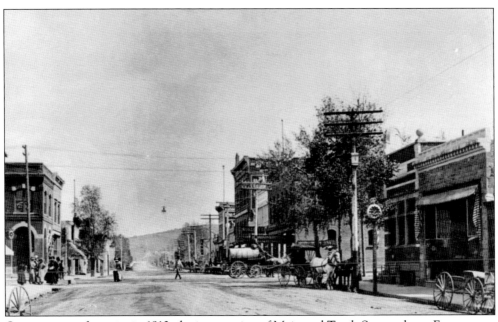

On a summer afternoon in 1910, the intersection of Main and Tenth Streets shows Evanston to be a bustling place. Between 1885 and 1910, Evanston saw a great building boom, during which almost all of the town's substantial public and commercial buildings were completed. More than a century later, many of them are still part of the downtown streetscape.

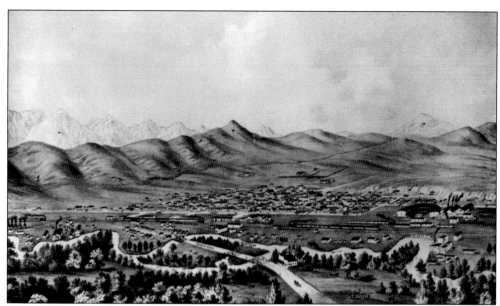

By 1875, just six years after it was platted, Evanston was well established. Its commercial district comprised a two-block-long stretch of Front Street (facing the railroad tracks) along with Main Street, one block to the west. The two streets had quite different characters.

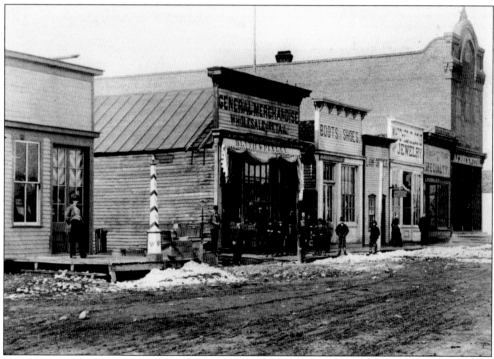

The earliest existing photograph of Main Street probably dates from the late 1870s or early 1880s. The street's identity as a retail business area is clear. The general merchandise store in the center of the picture was operated by Thomas Blyth and Charles Pixley. At the far end of the block was the two-story Beckwith store.

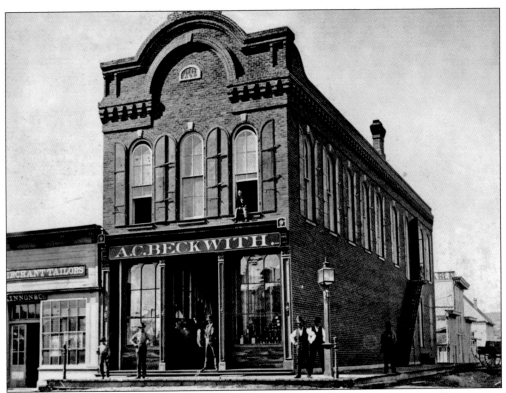

The A. C. Beckwith store building at the corner of Tenth and Main Streets was constructed in 1878, replacing an earlier wooden store dating from 1874. (Courtesy of the Beckwith family.)

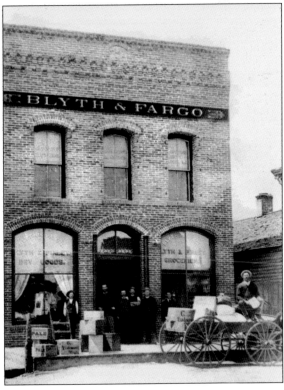

By 1890, Blyth and Pixley became Blyth and Fargo when Thomas Blyth took on new partner Lyman Fargo. The transition can clearly be seen on the company's brick structure, built in 1887. The new Blyth and Fargo sign above the second-story windows trump the "Blyth & Pixley" painted on the first-floor windows. A few years later, a third story was added to the building, which still stands at 937 Main Street.

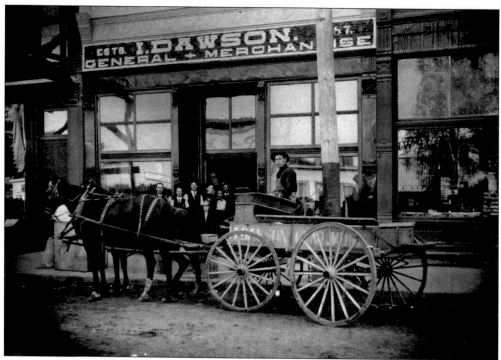

Dawson's General Merchandise store stood next to the Blyth and Fargo Company. In 1895, the business and the building also became part of the Blyth and Fargo enterprise. (Above, courtesy of Gary Cazin.)

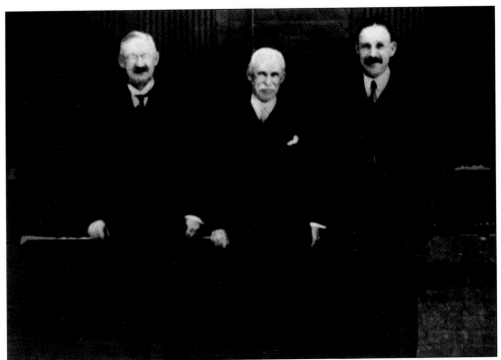

From left to right, partners Lyman Fargo and Thomas Blyth pose with grocery manager John Rennie in the early 1900s. Rennie later became general manager of the business. (Courtesy of UCL.)

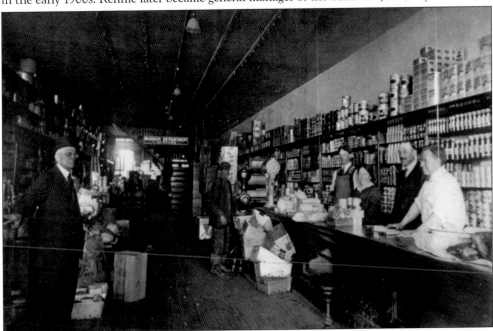

The Blyth and Fargo grocery department was full-service rather than self-service, with staff filling customers' orders. Customers could also call in their orders for delivery. Jimmy Anderson is the tall young clerk in the apron on the right. He began working for the company in the early 1930s. The other people are unidentified. (Courtesy of Blyth Art and Frame.)

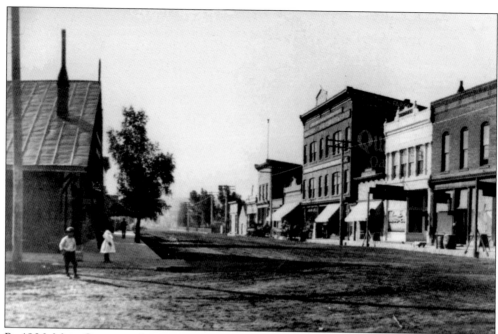

By 1906, Main Street was beginning to take on its familiar profile. At the corner of Tenth and Main Streets, the Beckwith and Lauder building on the far right had replaced the Beckwith store in 1890. It housed various businesses on the first floor and offices on the second. In mid-block, the three-story Blyth and Fargo building dominated the skyline as it still does today. The Beeman and Cashin implement barn can be seen on the left side of the intersection. Lester and Mary Guild were observers of the scene.

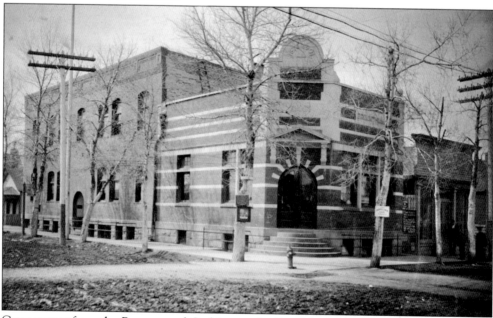

Catty-corner from the Beeman and Cashin was the First National Bank, which took over the Beckwith and Company bank building in 1907. The same bank (now known as First Bank) still occupies the building.

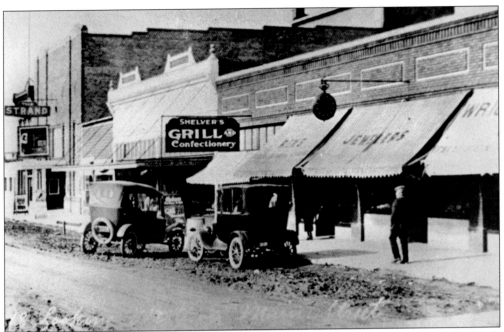

Farther northwest down Main Street, the Strand Theater (on the far left) anchored the block that housed a café, a jewelry store, and a drugstore.

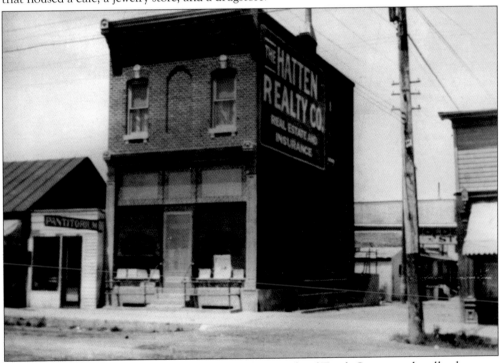

The Hatten Realty building stands on the northwest side of Tenth Street on the alley between Main and Front Streets. It was originally built in 1880 to house the North and Stone Bank, established by Orlando North and Charles Stone. The small shop on the left is a "Pantitorium"—a combination laundry and trouser-ironing business. (Courtesy of EURA.)

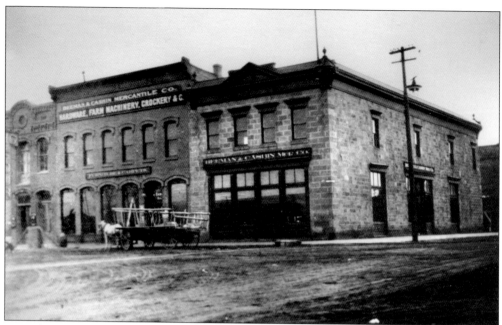

From the beginning, Front Street developed differently from Main Street. By the late 1880s, the block between Ninth and Tenth Streets featured three substantial business buildings. On the corner (on the right in the photograph) was a two-story stone building constructed by Sisson, Wallace, a general merchandise company. The Beeman and Cashin Company put up the brick structure next to it and eventually took over the corner building. The sign on the third building on the far left of the picture reads the Big Four Bar. (Courtesy of UCL.)

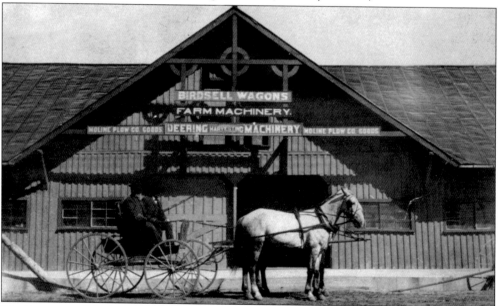

The Beeman and Cashin Company's merchandise stock included large farm and ranch equipment. Behind their stone building, they built a large wooden barn that extended along Tenth Street all the way to Main Street. The names of the men in the buggy are not known. (Courtesy of Gary Cazin.)

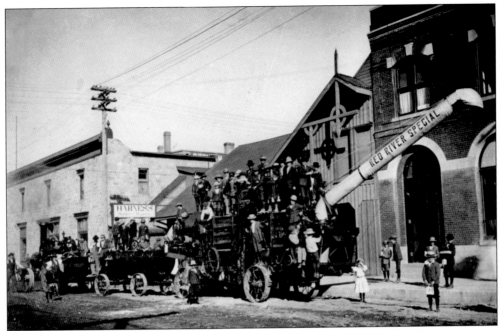

In 1907, part of the Beeman and Cashin barn was torn down to make room for the construction of the Evanston National Bank building at Tenth and Main Streets. The red-brick bank building is seen at the right in this photograph, which documents the arrival of a large new threshing machine in town. (Courtesy of EURA.)

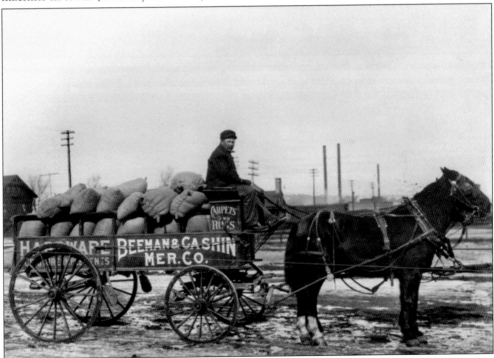

Delivery was a common service provided by general stores of the period. Here the Beeman and Cashin delivery wagon makes its rounds through town. (Courtesy of Sandy Ottley.)

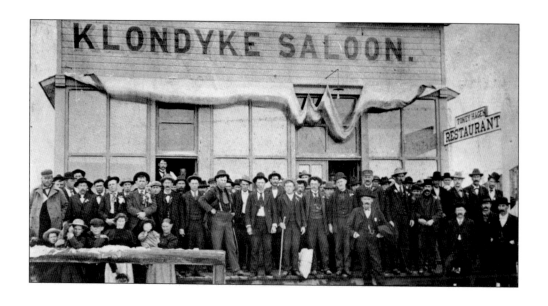

Front Street historically has been known for its bars, taverns, restaurants, pool halls, and similar establishments. The Klondyke Saloon, shown above, stood near the northwestern corner of Tenth and Front Streets. It was likely named for the gold strikes in the Alaskan Yukon at the end of the 19th century. The Opera Saloon, shown below, stood down the block from the Klondyke next to the Downs Opera House.

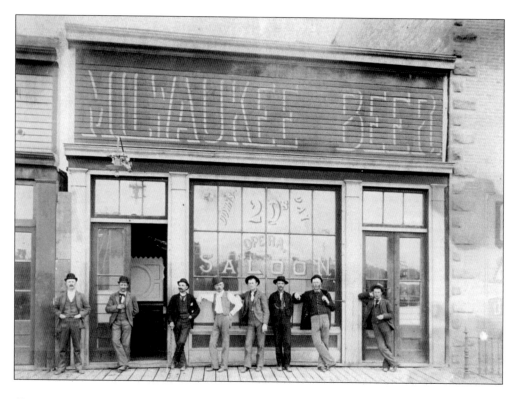

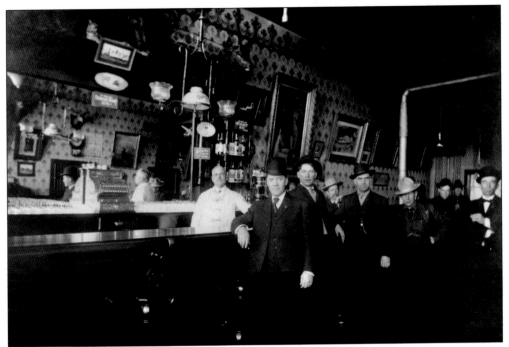

This undated photograph shows the interior of the Big Four Bar. It appears to have been an upscale establishment, judging from the furnishings and decor. The patrons are unidentified. (Courtesy of WSA.)

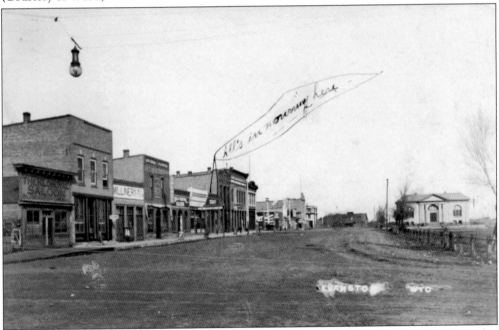

This postcard photograph shows Front Street sometime after 1906, when the Carnegie Library (on the right) was built. "All's in mourning here," says the balloon caption rising from the side of the building that housed the Big Four Bar. The second floor of that building was used as a brothel until well into the 1940s. Perhaps it is just as well that the addressee of the postcard is unknown.

By the first two decades of the 20th century, Front Street businesses included saloons, restaurants, hotels, and pool halls mixed in with retail stores. (Below, courtesy of Anna Lee Frolich.)

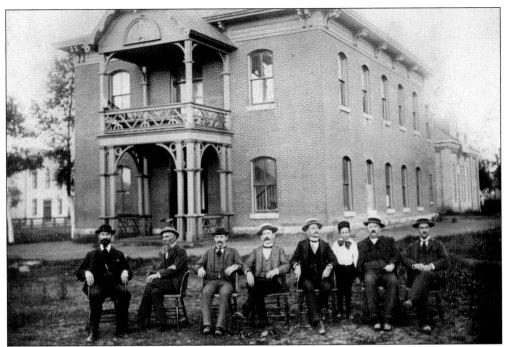

In addition to commercial buildings, Evanston's downtown also saw the construction of key public buildings during its first half century. The first of these was the county courthouse, constructed in 1874 with a $25,000 appropriation from the Wyoming Territorial Legislature. The courthouse, the oldest in Wyoming, was erected on the block bounded by Main, Ninth, Center, and Eighth Streets. The only man identified in this undated photograph is James Edward Burdett on the far left.

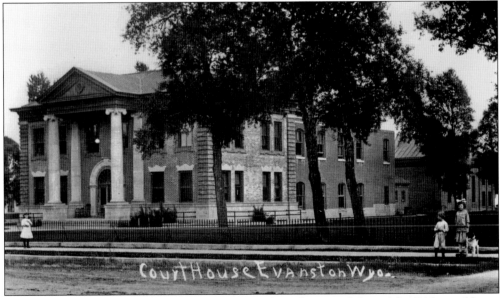

Behind the courthouse—obscured by the trees on the right—stood the jail. In 1910, an addition was built onto the front of the courthouse rather than the rear, leaving the jail undisturbed. During a second courthouse expansion in 1984, however, the jail was torn down.

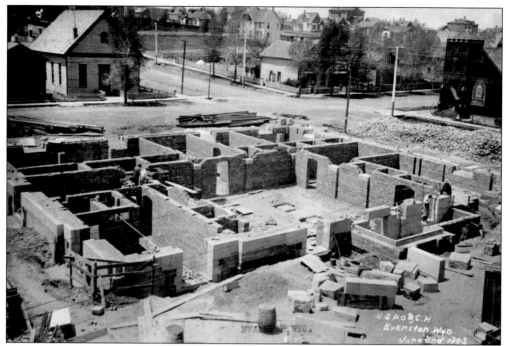

In 1905, construction began on a federal building to house a courthouse, the post office, and the land office. U.S. senator Clarence D. Clark of Evanston was likely influential in bringing the project to his hometown. The building stands at the corner of Tenth and Center Streets. The Union Presbyterian Church can be seen in the upper right corner, with the Methodist church in the upper left. (Courtesy of EURA.)

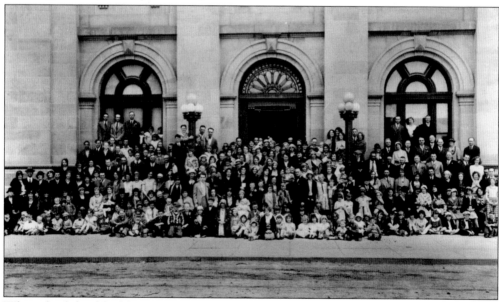

When the federal building was dedicated in 1905, the crowd that attended was captured in this photograph. Reportedly, the only case ever tried in the wood-paneled courtroom on the second floor was that of a bootlegger in the early 1920s. (Courtesy of American Heritage Center, University of Wyoming.)

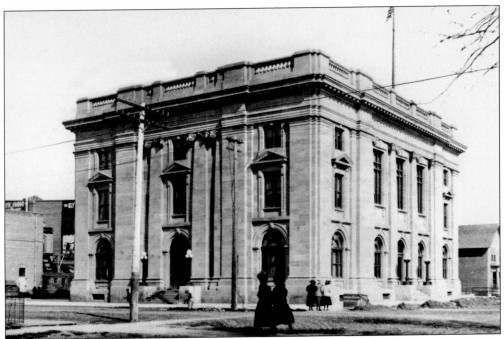

During World War I, the Red Cross was located on the second floor of the federal building. When the Spanish influenza pandemic hit Evanston in 1918 and 1919, the space was turned into an infirmary. Although the courtroom was not used after the 1920s, the post office remained on the first floor until the mid-1980s. The building is now privately owned and houses several businesses, but Evanston residents still call it the "old post office."

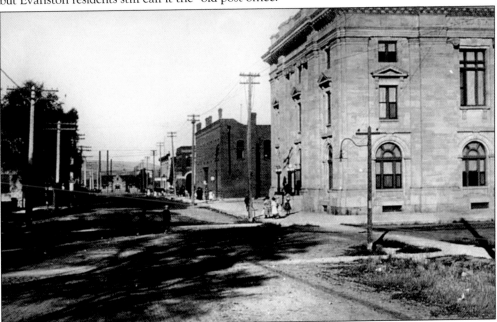

The federal building anchored the northwest end of Evanston's downtown. This photograph, taken sometime after 1907, shows the length of Tenth Street from Center Street to the Union Pacific passenger depot in the distance. (Courtesy of Anna Lee Frolich.)

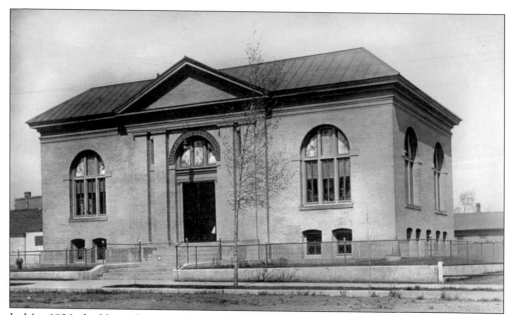

In May 1906, the Uinta County Library opened in a Greek Revival–style building. Construction of the library was funded with a $10,000 grant from Andrew Carnegie. New York architect Albert Randolph Ross designed the building. Carnegie's wife, Louise Carnegie, donated a piano, and the Ladies Literary Society of Evanston donated the books.

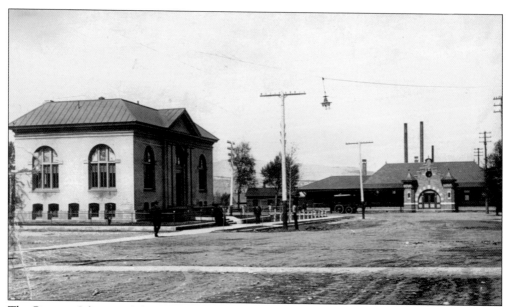

The Carnegie Library and the passenger depot, built in 1900, quickly became community landmarks. The tall slender chimneys behind the depot are those of the Evanston Electric Light Company plant, across the tracks from the depot, which provided power and light for the town.

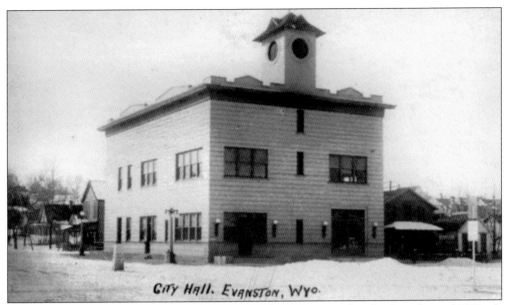

City Hall. Evanston, Wyo.

After a heady start in 1869, Evanston's municipal government dissolved in the mid-1870s. It was reestablished in 1888 and occupied rented space in various locations in town until 1915, when Evanston's first town hall was completed on the corner of Main and Eleventh Streets. The two-story structure featured a clock tower and housed not only the town offices but also the fire department. The large door on the right was for the fire equipment. The building, now privately owned, served as Evanston's city hall until 1984.

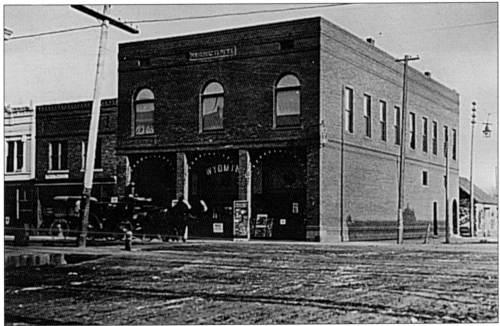

The Masonic temple, completed in 1910 at the corner of Main and Ninth Streets, helped define the downtown streetscape. Over the years, the ground floor has housed a movie theater, ice cream parlor, dance hall, and a variety of retail businesses, while the upper floor has continued to be dedicated to Masonic Lodge meeting rooms. (Courtesy of UCL.)

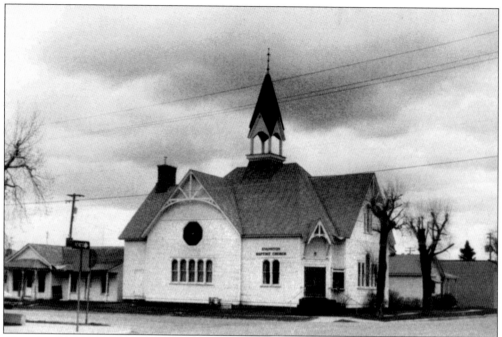

Churches have been a part of the Evanston landscape from the beginning. The Methodist congregation was organized in 1870, followed by the Baptists and the Presbyterians in 1871, the LDS (Latter-day Saints) in 1872, and the Episcopalians and the Catholics in 1873. The Evanston Baptist Church, shown here, was built around 1877 at Eighth and Center Streets. (Courtesy of Helen Morrison.)

The first LDS church in Evanston was built at the corner of Main and Seventh Streets in 1889.

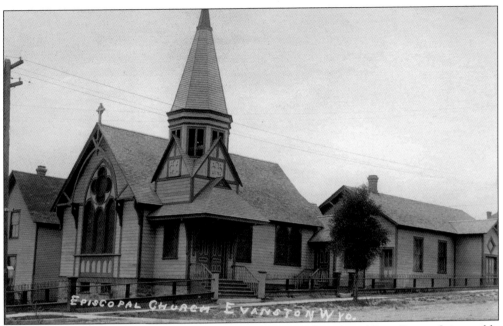

St. Paul's Episcopal Church was built in 1884 at the corner of Tenth and Sage Streets. It is notable for its beautiful stained-glass memorial windows.

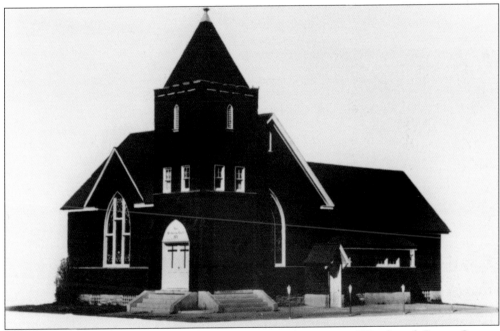

The Union Presbyterian Church was built in 1900 at the corner of Tenth and Center Streets. An extensive remodeling and expansion in 1920 added a steeple and moved the front door from Center Street to Tenth Street around the corner.

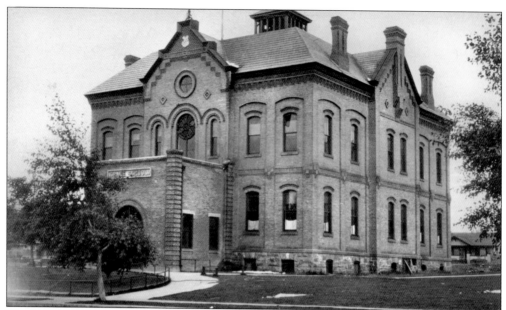

The first classes in Evanston were held in various locations around town, including a room above a Front Street saloon, Union Presbyterian Church, and various homes. Pictured here is the first school building, constructed in 1885 on Summit Street. The school was named for E. S. Hallock, who served as school superintendent from 1883 to 1888. This impressive building was torn down in the mid-1930s.

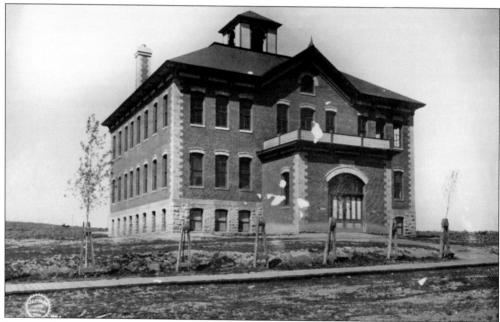

In 1903, the growth of the school population led to the construction of a new high school building on Twelfth and Summit Streets. It was originally called West Side High School. Then in 1915, with the construction of a larger high school facility, this building was converted to a grade school and renamed Clark School in honor of U.S. senator Clarence D. Clark, an Evanston resident. (Photograph by J. E. Stimson; courtesy of WSA.)

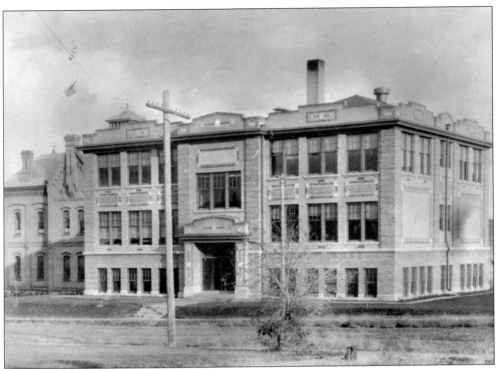

Evanston High School on Tenth and Morse Lee Streets opened in 1915. It served as the high school until 1933, when yet another high school building was constructed at the east end of the block. The building pictured here then became Evanston Junior High School. It now houses the school district offices. (Courtesy of UCL.)

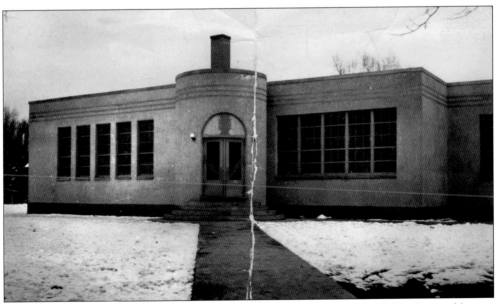

Evanston built two three-grade schools for the youngest students in the 1920s. Pictured here is Brown School, located on Second Avenue in North Evanston. It was in use through the 1970s.

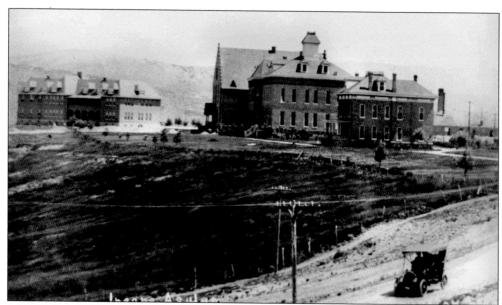

In 1887, Evanston was designated as the location for the Wyoming State Asylum for the Insane by the Wyoming Territorial Legislature. The hospital was built on 160 acres one mile south of Evanston. In 1897, the name of the institution was formally changed to the Wyoming State Hospital for the Insane, later abbreviated to Wyoming State Hospital. Under the direction of Supt. C. H. Solier, head of the institution from 1891 until his death in 1930, the hospital developed into a stately campus of red-brick buildings grouped around a broad lawn dotted with trees. Shown in this photograph from around 1915 are the Women's Building on the left, the Main Building in the center, and the superintendent's residence on the right. Hundreds of Evanston residents have staffed the hospital since its inception.

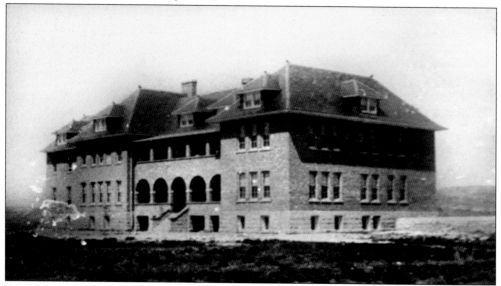

The Women's Building at the state hospital—also called Brooks Cottage after Wyoming governor B. B. Brooks—was completed in 1910. It was intended to house female patients in a pleasant, home-like atmosphere. The interior furnishings included wicker furniture and a piano. The colonnaded porches on the first and second floors provided access to fresh air.

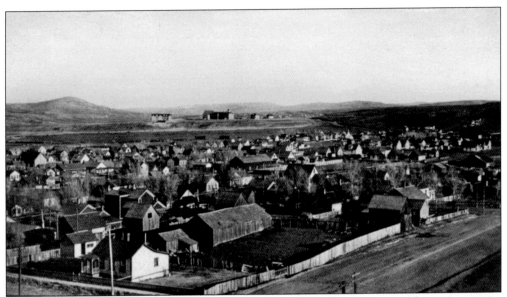

This view across Evanston's rooftops, taken between 1910 and 1917, reveals the isolation of the state hospital from the town. (Photograph by J. E. Stimson; courtesy of WSA.)

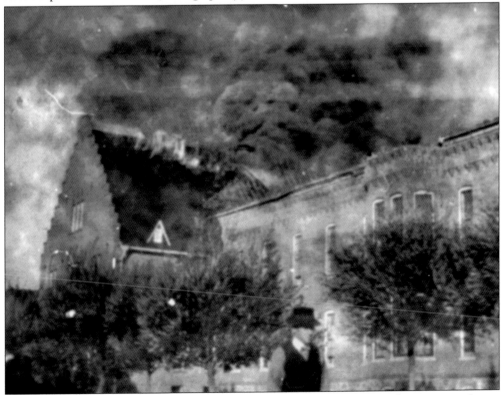

The original hospital building, opened in 1889, was a large structure with two wings. It was intended to house both patients and staff, although the first superintendent, Dr. W. A. Hocker, had a private residence constructed on the campus for his family. The 1889 hospital building was destroyed by fire in 1917. (Courtesy of Karma Osborn.)

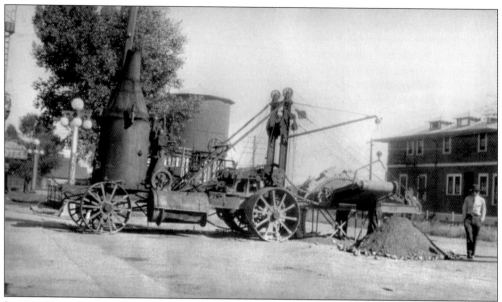

In 1920, Evanston installed a municipal water system, drawing water from the Bear River upstream and piping it to a reservoir on Sulphur Spring Hill on the southeastern edge of town. Cast-iron main lines and wooden feeder lines were installed throughout the town. The entire process was documented in a photograph album put together by the Prince Nixon Engineering Company, who designed the system and oversaw its implementation.

Final inspection of the water system was done by the project engineer Prince Nixon, Mayor John Romick, contractor George M. Carruth, town council member John Cheese, and building inspector George Hobart Chapman.

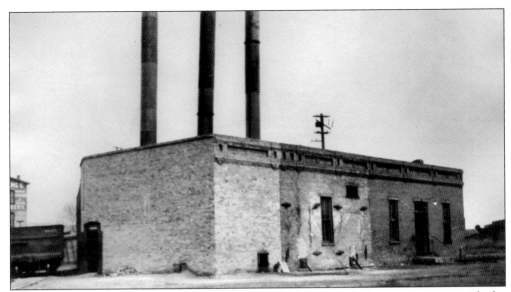

The Evanston Electric Light Company was established in 1888. Its first contract was with the Town of Evanston to provide street lighting. The generating plant was built along the Bear River across the tracks from the depot on the north edge of Chinatown. Large ducts carried excess heat generated by the coal-fired boilers under the tracks to buildings on Front Street. These ducts led to rumors of secret tunnels throughout downtown. In a story called "Hoboes That Pass in the Night," writer Jack London described spending a cold winter night in the Evanston electric plant. (Courtesy of UCL.)

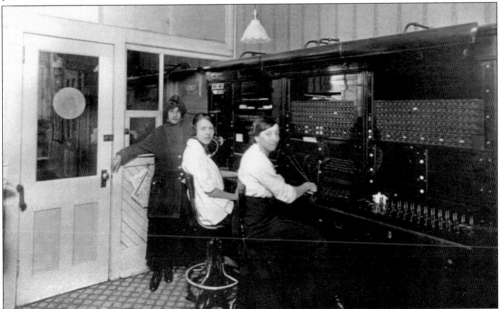

The phrase "number, please" came from these operators at the central telephone office in a photograph taken around 1912. The chief operator was Emma Dunning, shown here on the right. In addition to connecting telephone subscribers with one another, the operators were also responsible for fielding emergency calls. The fire department directory for this period instructs callers to "take the receiver off the hook and wait until Central answers."

Evanston is justly proud of its volunteer fire department, founded in 1886. Pictured here is the fire department's competition hose team, led by J. T. Clark. (Photograph by J. E. Stimson; courtesy of WSA.)

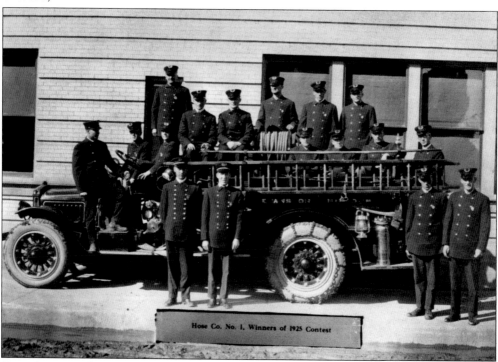

Hose Co. No. 1, Winners of 1925 Contest

Over the years, the fire department's hose companies consistently won statewide competitions. Here the winning team from 1925 posed in front of the town hall. (Courtesy of WSA.)

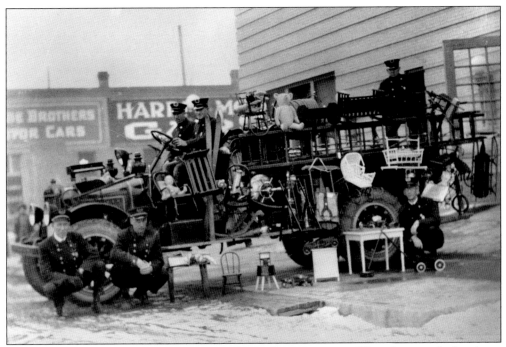

Then, as now, the fire department loved to show off its equipment. This photograph also shows the generosity of the volunteer firefighters who are displaying the results of a Christmas toy drive. (Courtesy of EURA.)

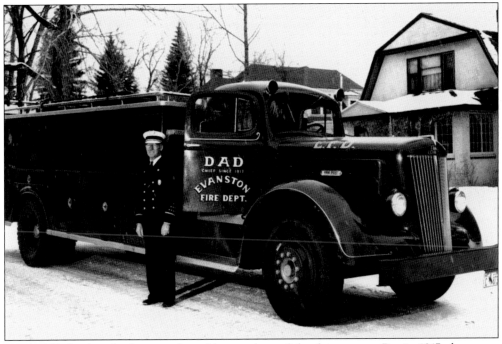

Until 1917, the fire chiefs were selected by members of the department. But in 1917, the mayor and town council began appointing chiefs. Their first selection was David A. Davis, who served as fire chief until 1955. He was the only chief to have a piece of equipment named for him.

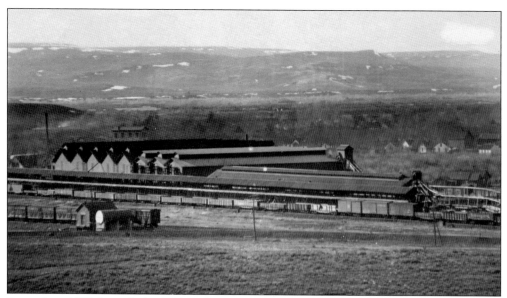

From about 1897 through the 1920s, a distinctive feature of the Evanston landscape was its icing station, one of a series created as a joint venture between the Union Pacific Railroad and the Pacific Fruit Express Company of California. By 1914, the station comprised two large ponds, created by diverting the Bear River, and nine large wooden icehouses located along the tracks. (Courtesy of EURA.)

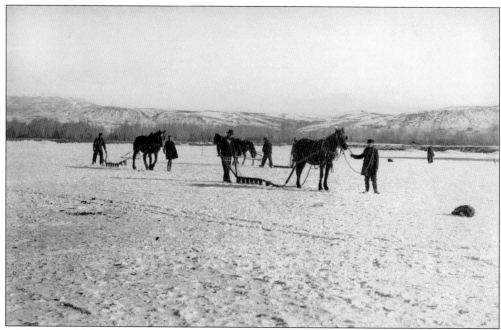

Workers on the ice ponds used large horse-drawn saws as well as handsaws to harvest blocks of ice from the ponds in the winter. Many of the ice pond workers were Italians, Greeks, and Turks who lived in small shacks on the edge of the icing station.

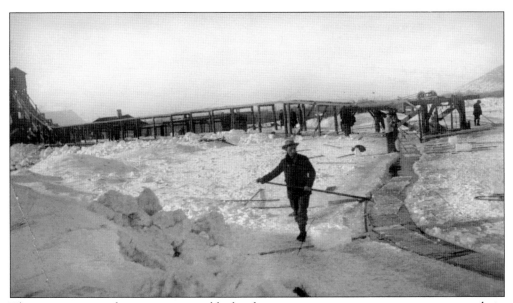

This ice station worker is moving ice blocks along a narrow waterway to a conveyor trestle in the background. The conveyor carried the blocks to the icehouses, where they were packed in sawdust produced by a nearby sawmill.

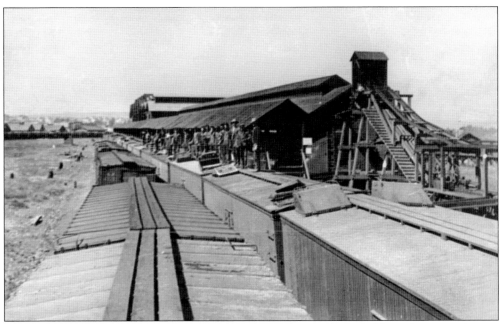

When produce cars arrived at the icing station, ice blocks were delivered from the storage houses via conveyor to a long shed next to the tracks. Men used tongs to carry and drop blocks of ice into hatches at either ends of the cars. (Courtesy of WSA.)

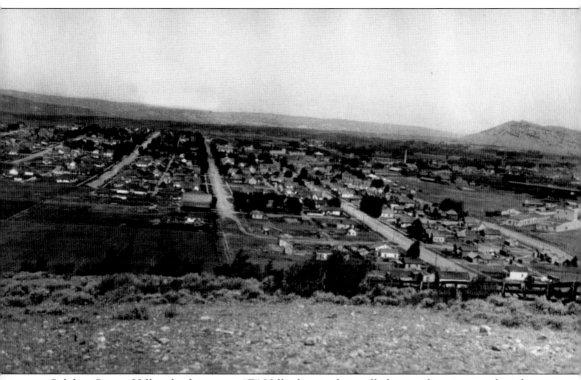

Sulphur Spring Hill—also known as "E" Hill—has traditionally been a favorite spot for taking photographs of Evanston because its height lets the photographer take in the entire community. This shot was taken in 1921.

Three

ALL AROUND THE TOWN

Naomi Whittle
(Petersen)

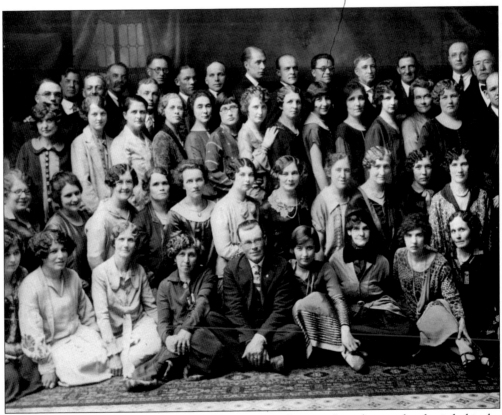

A town is more than just buildings and businesses, of course. It is the people who inhabit the place that make it a real community. The Uinta County Museum has no record of who these people are, but they gathered together for a picture in the Baker Photography Studio on Main Street sometime in the 1920s.

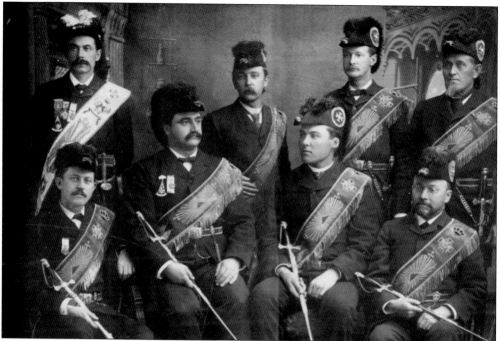

The Evanston Lodge of Free and Accepted Masons was established in 1873, the fourth Masonic lodge in Wyoming. Many of its charter members were prominent business and professional men in Evanston. Pictured here are, from left to right, (first row) George Goble, Andrew Leggitt, John Beckwith, and George Tracy; (second row) Frank Foote, Charles Stone, William Lauder, and Anthony Quinn. The photograph is undated but was likely taken in the 1880s. The lodge is still active. (Courtesy of Evanston Masonic Lodge.)

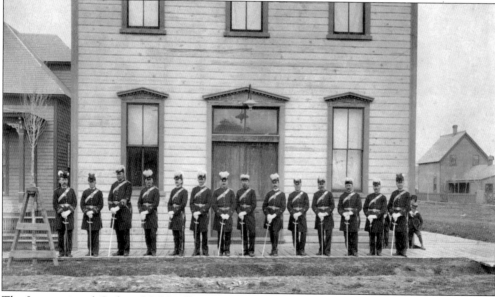

The International Order of Odd Fellows (IOOF) also established a chapter in Evanston in the 1870s. This 1889 photograph of the lodge members in full regalia was taken in front of the Odd Fellows Hall at Main and Eighth Streets.

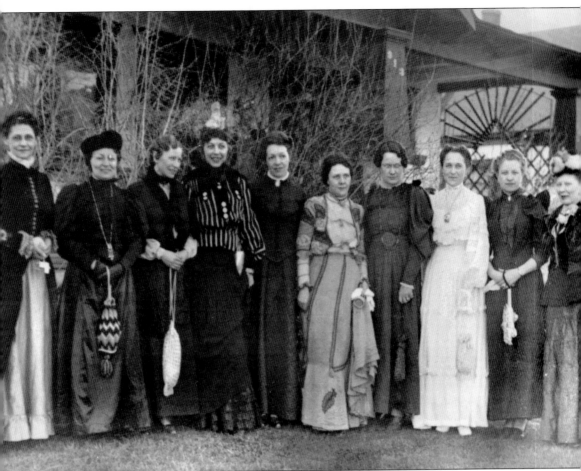

In the 1880s, women all over the United States began forming clubs devoted to the study of literature, history, and politics as a means of self-education. In 1895, Evanston's Ladies Literary Society was founded with a dozen charter members drawn from the community's social elite. Club members read original reports, performed music, and staged plays. This undated photograph, probably from the late 1930s or early 1940s, shows members in period dress. They include, from left to right, Florence Terry, Frances Chapman, Florence Murphy, Marnie Cook, Marie Pehl, unidentified, Ethel Kelly, Vera Lloyd, Mildred Cue, and Edith Anderson.

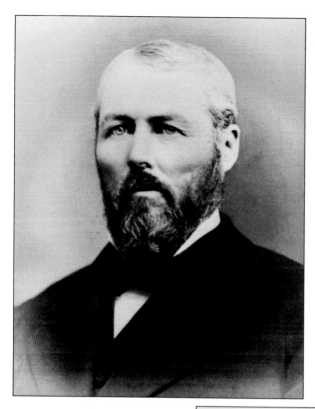

Asahel Collins Beckwith came to Evanston in 1873. An energetic entrepreneur, he partnered with William Lauder to open the Beckwith and Lauder store on Main Street in 1874. With partner A. V. Quinn, he contracted with the Union Pacific to supply Chinese laborers for the coal mines at Almy and established the BQ Ranch on the Bear River downstream from Evanston, one of the largest cattle ranches in Wyoming Territory at the time. (Courtesy of the Beckwith family.)

Mary Ernestine Stuart Rose Beckwith was A. C.'s wife and a well-educated woman. She was active in St. Paul's Episcopal Church until her death in 1894. A large part of her personal library formed the foundation for the county library's collection. (Courtesy of the Beckwith family.)

The early entrepreneurs of Evanston helped establish the tone of the residential neighborhood southwest of downtown. While railroad workers lived in small houses close to the tracks, wealthier residents built their homes farther up the hill. A. C. Beckwith built this large home at 324 Center Street in the 1880s. The house was later owned by Dr. L. E. Fosner, who used part of it as a sanitarium. (Courtesy of the Beckwith family.)

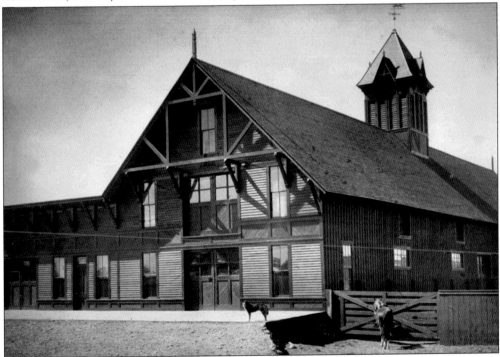

West of the Beckwith house was the Beckwith Stock Farm, where A. C. raised horses. The farm featured this handsome barn and stables.

George F. Chapman, shown here on the left with his cousin Spencer Otis, posed for this portrait on his way to Evanston from his home in Connecticut around 1880. He worked for the railroad for several years before starting a ranch, the Neponset Land and Live Stock Company, with his two brothers, William and J. E. The brothers also opened the Neponset Market on Main Street, where they sold meat raised on the ranch. George's stately house on Summit Street still graces the neighborhood. (Both, courtesy of Anna Lee Frolich.)

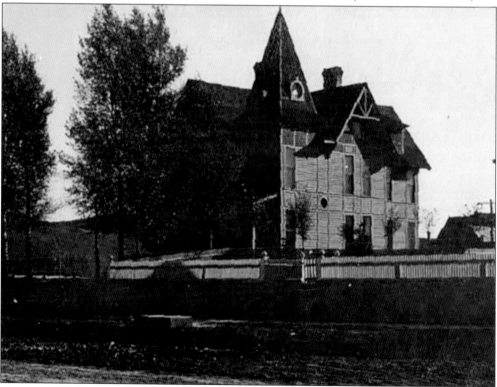

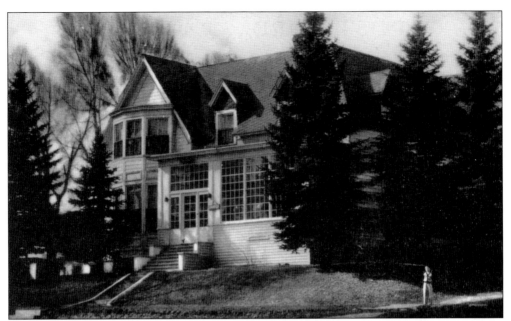

A. V. Quinn built this showpiece home in 1885 on the corner of Center and Eleventh Streets. The Quinn home has served over the years as a boardinghouse and a bed-and-breakfast inn.

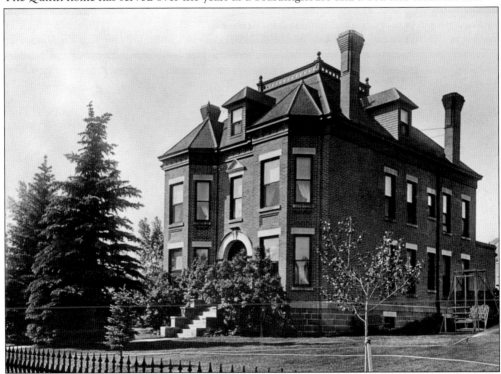

This handsome brick home was built by Thomas Blyth, founder of the Blyth and Fargo Company, at the corner of Summit and Tenth Streets. It is sometimes referred to as the "old hospital" because a local doctor housed patients there in the 1930s. In the 1950s, it was divided into apartments. (Courtesy of WSA.)

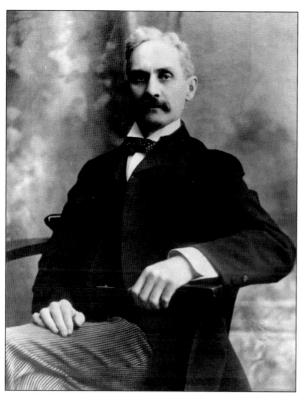

Attorney Clarence Don Clark moved to Evanston in 1881. In 1890, he was elected the first U.S. Congressman from the newly minted state of Wyoming. He later served three terms in the U.S. Senate from 1895 to 1917. (Courtesy of UCL.)

Senator Clark's home at Summit and Eleventh Streets was another showplace in Evanston's residential neighborhood. (Courtesy of the Utah State Historical Society.)

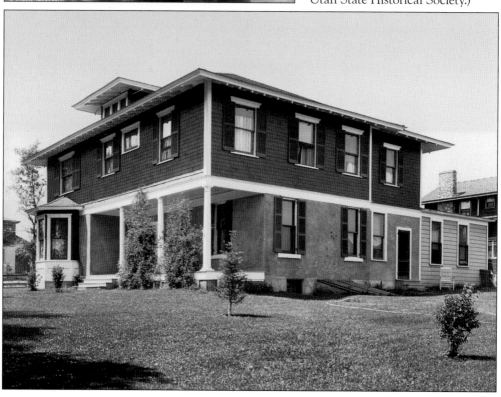

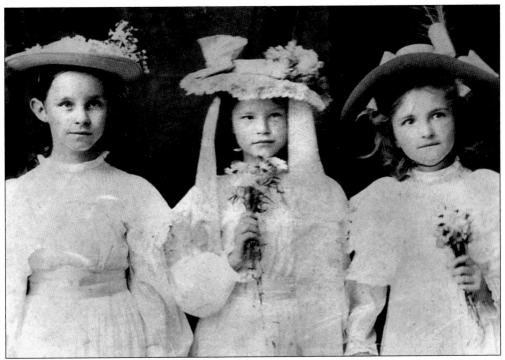

Margaret (left) and Frances (center) Clark were two of Senator Clark's daughters. Here they pose with their friend, Beth Chapman (right), around 1900. (Courtesy of Anna Lee Frolich.)

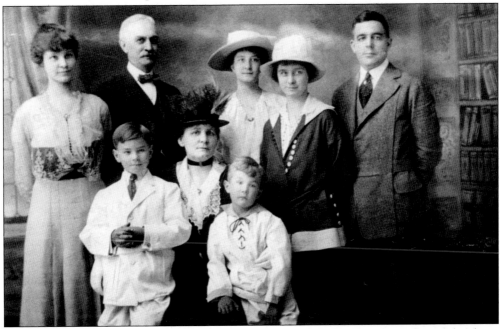

Senator Clark, second from left in the back, poses with his wife, Alice (seated), and daughters Laura (left), Frances (third from left), and Margaret (fourth from left). Margaret's husband, Josiah Holland (right), became one of Evanston's most beloved physicians. He met Margaret in Washington, D.C., where she was attending school during her father's term as senator.

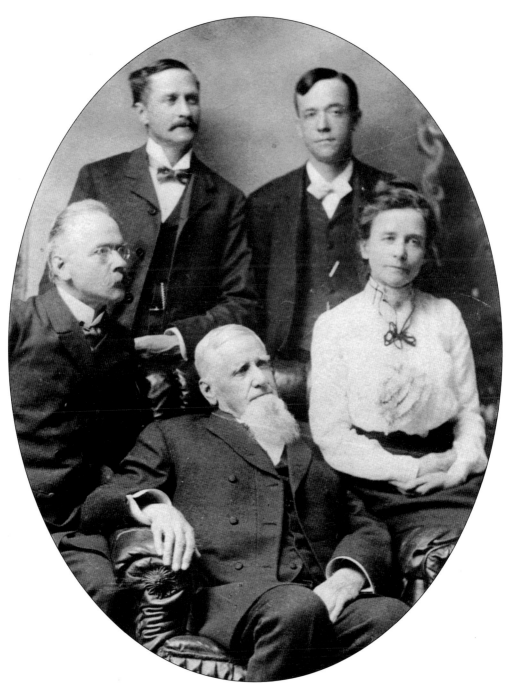

Rev. Franklin L. Arnold (seated) took over pastorship of the fledgling Union Presbyterian Church in 1875 and served as pastor until 1888. His son, John (on his father's right), held many public offices, including county clerk, county treasurer, county attorney, and Evanston's mayor. In 1915, he was appointed judge of Wyoming's Third Judicial District. Daughter Elizabeth married banker and businessman Charles Stone. A poet and songwriter, she was a charter member of the Ladies Literary Society and wrote the only published history of the community, *Uinta County, Its Place in History*, in 1924.

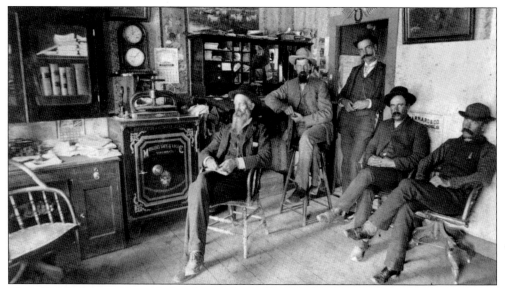

This glum-looking group includes, from left to right, Frank Moore, Edward Skinner Crocker, Harvey Booth, William Crawford, and William Thompson. All but Moore were partners in a ranch north of Evanston. The picture was taken sometime before January 26, 1893, when William Crawford disappeared after leaving home to attend a dance at the Masonic Hall. Two years later, to the day, Harvey Booth was found murdered in his own livery stable at the corner of Tenth and Center Streets. E. S. Crocker was charged with the murder but acquitted in two separate trials. (Courtesy of UCL.)

Harvey Booth's three children—Harvey Jr., James, and Emily—share a moment with their father in front of the Julian House at Ninth and Sage Streets in Evanston.

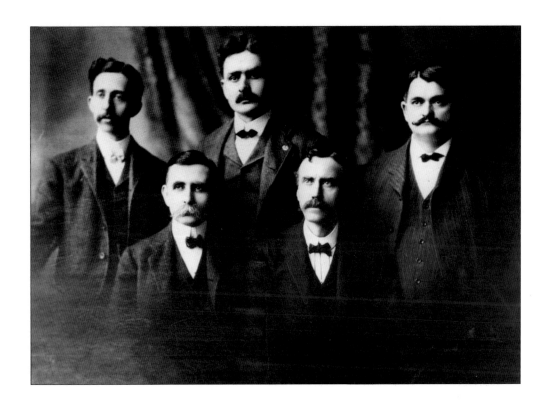

The partners of the Golden Rule department store chain hired young J. C. Penney in 1899 to work in their Evanston store on Front Street. Three years later, they made him a partner and sent him to the town of Kemmerer to open a new Golden Rule store there. Within a few years, Penney had bought out the partners and established a new business that carried his name. (Above, courtesy of UCL.)

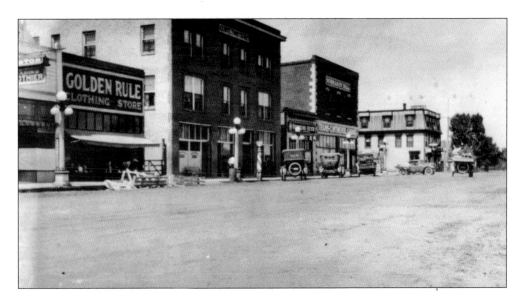

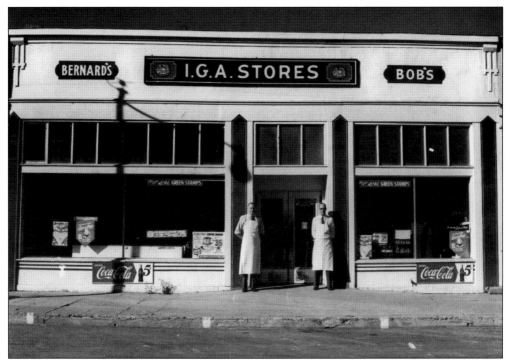

From left to right, Bernard Green and Robert Cousins stand beaming in front of their new IGA grocery store on Main Street in 1949. The store was originally the Neponset Market. Green and Cousins purchased it from the Howard Mosey family, who had operated it for nearly 50 years.

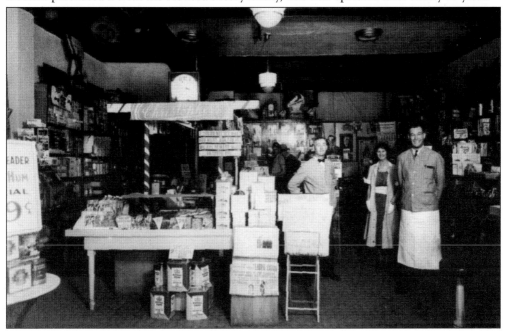

Located on Tenth Street between Main and Front Streets, Bert Dunning's confectionery and tobacco shop was a popular spot. Bert Dunning (left), daughter Josephine, and son Bert Jr. are shown here ready for customers in 1934. (Courtesy of Edie Bell.)

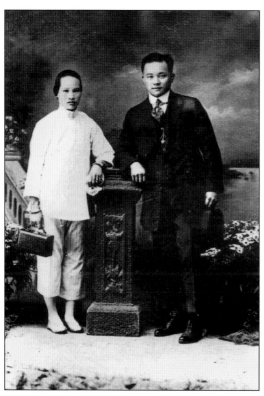

In 1918, a young Chinese immigrant named Wong Gin Wing arrived in Evanston. He purchased a café next to the Ranch Saloon on Front Street. Three years later, he brought his wife, Mah Shee, to Evanston. (Courtesy of Wayman Wing.)

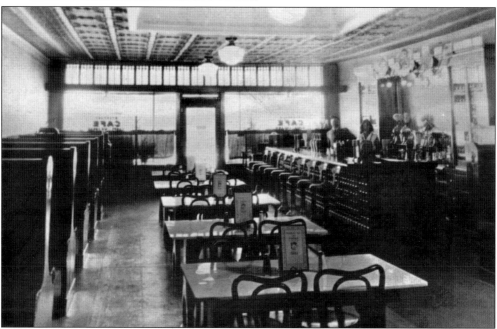

Together the Wings operated several successful restaurants, including the Ranch Café, the Standard Café, and the White House Café. The White House was on Tenth Street and the Standard was around the corner on Front Street, but they shared the same kitchen. All three restaurants served both Chinese and American food. (Courtesy of Wayman Wing.)

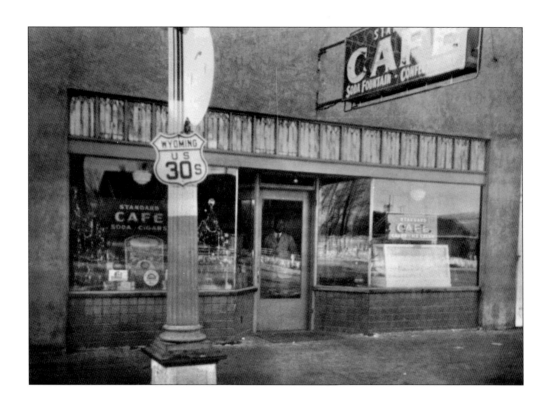

The Ranch Café at 925 Front Street had a more formal atmosphere than the other two Wing restaurants. According to one Evanston resident, "Everyone I know worked at the Ranch Café at one time or another." During the 40 years that the Wings lived and worked in Evanston, they raised six children and sent all of them to college. (Both, courtesy of EURA.)

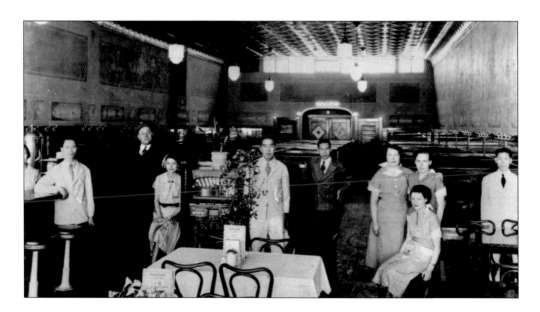

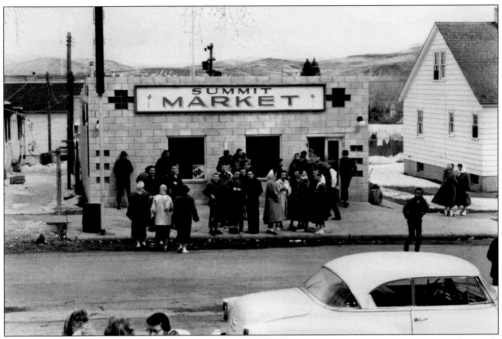

In 1952, Kenneth and Maud Morgan opened the Summit Market on Summit Street near Eleventh Street, directly across from Evanston High School. At first, the store only sold candy and school supplies, but it soon expanded into a neighborhood grocery that was open in the evenings after other markets were closed. It closed in 1978.

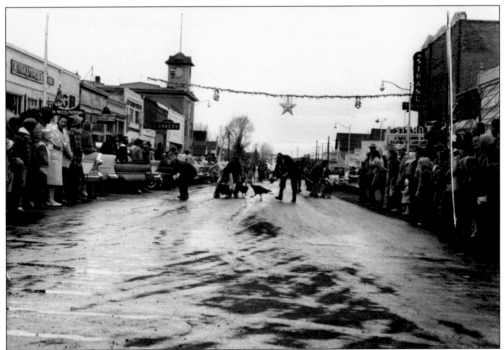

This turkey race on Main Street sometime in the late 1950s or early 1960s brought a good-sized crowd downtown on a wet, gloomy day. (Courtesy of EURA.)

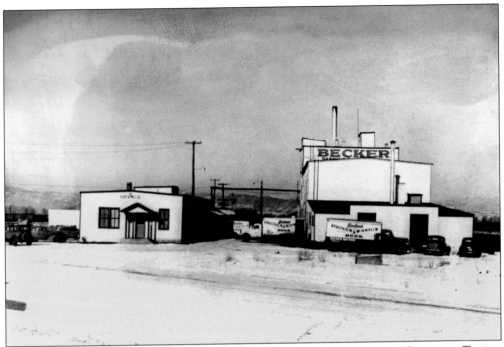

In 1917, the Becker Brewing Company of Ogden, Utah, built a brewery in Evanston. Timing was poor for Becker, however, as Prohibition was instituted just three years later. The brewery sat idle until 1933, when the repeal of the Volstead Act made it legal again to manufacture beer. The Evanston plant produced Uinta Club as well as a nonalcoholic beverage called Becco until the late 1950s.

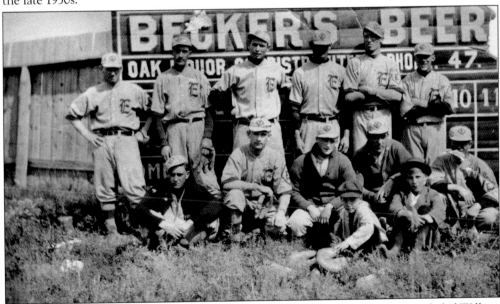

Becker Brewery sponsored a local baseball team in the late 1910s. Team members included William Crawford, Rennie Dawson, Dewey Anderson, Walter Foley, Clarence Cook, Roy Crompton, Roy Eastman, John Mills, John McQuaig, Justin "Red" Smith, Ronald Judd, Hershel Stonebraker, and Thomas T. Nelson.

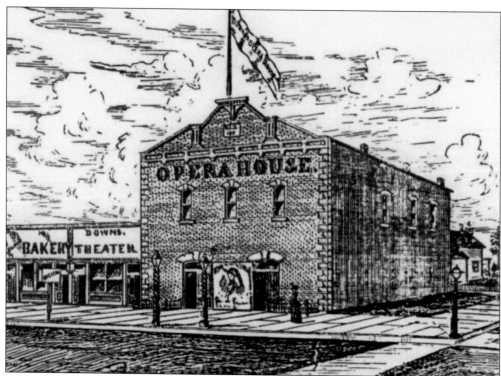

As a railroad town, Evanston never lacked for entertainment. Downs Opera House, constructed in 1885, provided a venue for theatrical troupes traveling by train around the country. (Courtesy of Karma Osborn.)

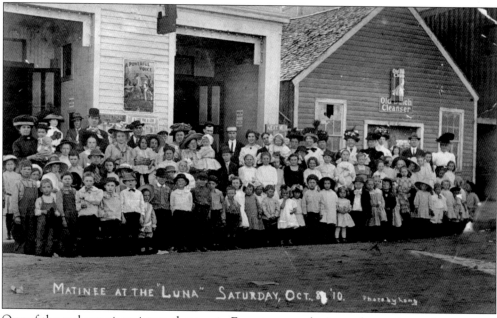

One of the early moving picture theaters in Evanston was the Luna, located near the corner of Main and Ninth Streets. These children seem to have dressed up for the matinee.

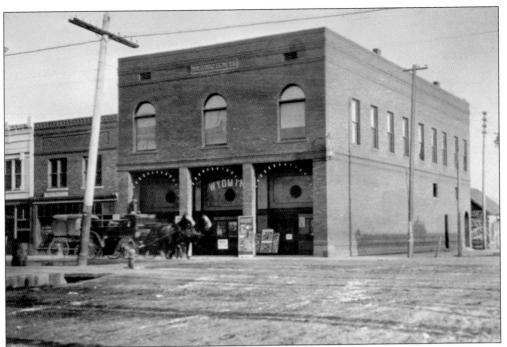

When the Masonic Temple was built in 1910, the first floor was constructed as a theater for both movies and live performances. The theater, called the Wyoming, operated until 1917. (Courtesy of WSA.)

In 1917, the Strand Theater was the first building in town intended specifically for both movies and live performances. Decorated on the inside with Egyptian motifs, the Strand hosted vaudeville and variety acts through the 1940s, as well as showing three or four movies a week. A disastrous fire in 2007 nearly destroyed the building; preservationists are now at work to bring new life to it.

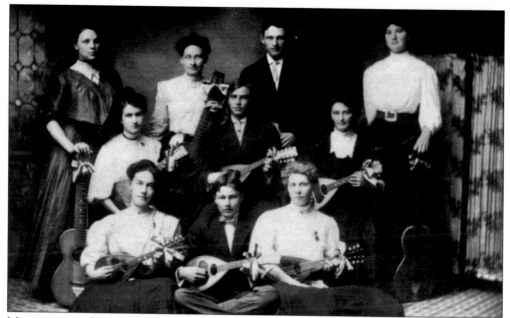

Music seems to have been a significant part of local community life from the beginning. And even though Evanston was a small town in the Mountain West, it kept up with national trends. One such national fashion was mandolin clubs in the first two decades of the 20th century. This Evanston club featured both guitars and mandolins. Unfortunately the names of the players went unrecorded.

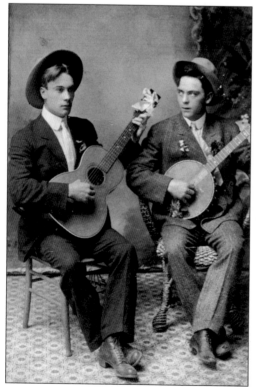

Mass production of musical instruments like mandolins, guitars, and banjos reduced their cost and made them accessible through catalogs like Sears, Roebuck, and Company and Montgomery Ward. Here John Gilmore on guitar and William Wagstaff on banjo pose for a formal portrait. (Courtesy of Flora Wagstaff.)

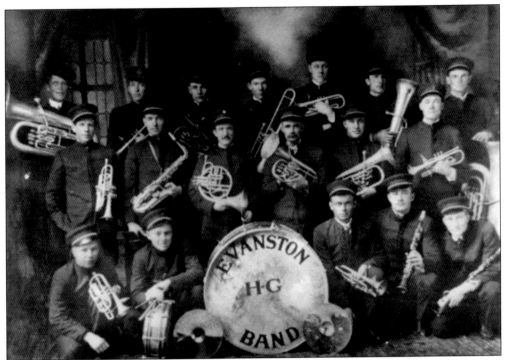

The concept of a Home Guard or local militia grew up in the United States in the 1910s. The Evanston Home Guard Band, shown here, served as the city band. Unfortunately, no one recorded the names of the members.

Here the Evanston Home Guard Band performs in a parade on Main Street in the late 1910s. It must have been a warm summer day because most of the band members have shed their coats.

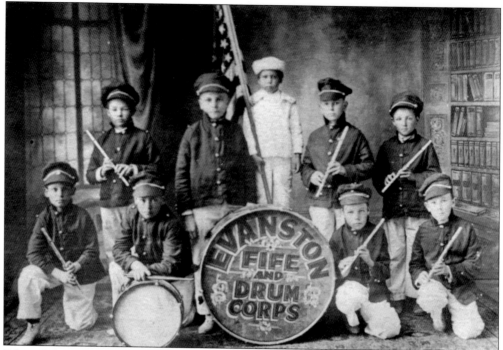

Fife and drum corps organizations for boys were popular around the United States during and after World War I. Only one member of this Evanston boys' group is identified: Louman Emert, the fifer to the right of the drum.

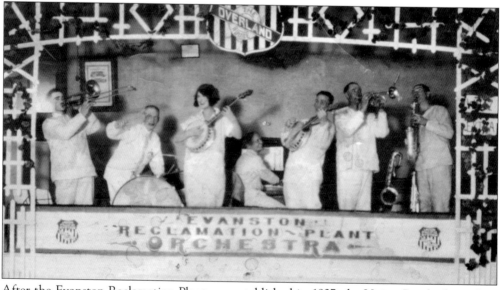

After the Evanston Reclamation Plant was established in 1927, the Union Pacific formed an orchestra that played for public functions and private parties around southwestern Wyoming. The members included Rudger Davis, Ferdinand Kohlenberg, Walter Shaw, Elmer Davis, Bob Skyles, Marion Skyles, Elmer Danks, and Mary Know.

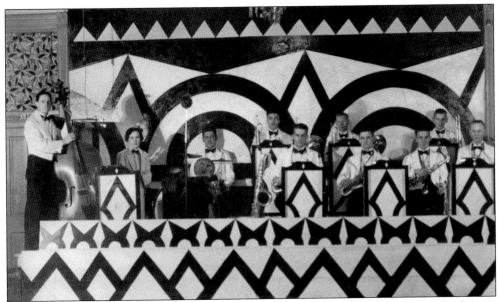

The Jim Horne Orchestra performed from the late 1920s into the 1930s. They were also known as the Blue Bucket Orchestra because they played in the Blue Bucket dance hall in the Odd Fellows Hall on Main Street. From left to right, the members were Jim Horne, bass; Isabella Dunning, piano; Harry Ehlers, drums; Marlow Paul, trumpet; Dale Cluff, saxophone; Loren Bird, trumpet; Tuffy Shaw, saxophone; Elwood Smith, saxophone; Dan Pickering, trombone; and Ron Davis, saxophone.

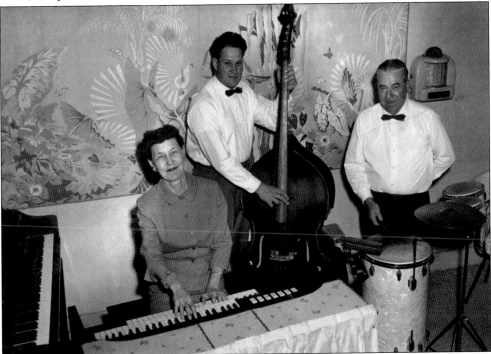

The Blackie Davis Trio played in the 1940s. They included Mary Frank on the piano, Fred Kallas on the bass, and Blackie (Walter) Davis on the drums.

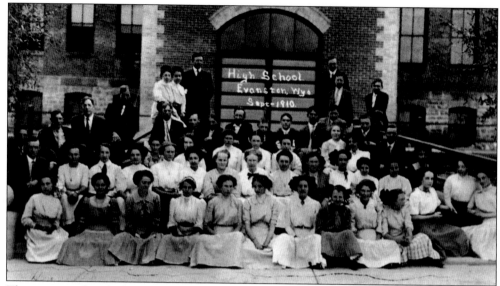

The entire student body of Evanston High School gathered for this postcard photograph at the beginning of the school year in 1910. Frank LaChapelle, one of the boys in the picture, sent the postcard to Charles Arnold.

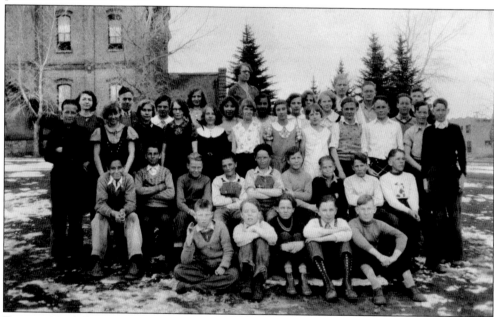

Evanston's eighth graders posed with their teacher, Caroline Murphey, in April 1933. The students are, from left to right, (seated on the ground) Charles Carpenter, Chester Carpenter, Russell Covey, Joseph Guild, and Richard Barnard; (seated in chairs) Ronald Blackman, Virgil Barnes, Eugene Picknell, Dewey Benzley, David Haines, Norman Smith, James Maltby, Jack Spencer, and Emerson Hartzell; (standing) Billie Davis, Ruth Sharp, Joseph Brown, Cora Barnes, Helen Huhtala, June Danks, Laura Burdett, Bethy Burbank, Kathleen Blair, Margery Hill, Clara Jane Knoden, Bertha Burkus, Mary Bricken, Marion Warbuton, Helen Goode, Alice Warbuton, Knute Larson, Harold Saxton, Charles Eardele, Billy Stevens, Carl Rapp, Clarence Holmes, Robert Haines, and Billy Faulkner.

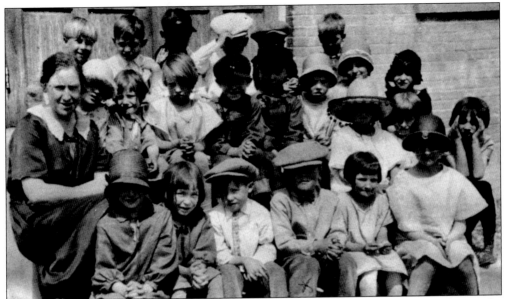

These first graders at Brown School peered into a bright sun to have their picture taken in the 1920s. From left to right are (first row) Lillian Bennett, Yvonne Price, Ralph Clary, Dewey Benzley, Demander Maxine Goodwin, and Loretta Benjamin; (second row) teacher Violet Gerrard, Oda Anderson, Phyllis Smith, Alice Benjamin, Charles and Chester Carpenter, Mary and Katherine Kenney, Grace McCarty, June Brown, and Annie Ellen Anderson; (third row) Leland Ewer, David Titmus, Ernest Renelle, Tom Morris, Bryon Woods, and Leland Ewart. (Courtesy of Karma Osborn.)

This 1910 report card for a 12-year-old student at the Hilliard School south of Evanston reveals that the school year ran from April through November and the pupils studied the fundamentals.

Report for the Year beginning April 25 190__ and ending Nov. 28 190 0													
BRANCHES PURSUED, ATTENDANCE, DEPORTMENT, ETC.	YEAR OF COURSE OF STUDY ENTERED	MONTH'S WORK TAKEN UP	STANDINGS BY THE MONTH									AVERAGE	BEGIN NEXT YEAR
			FIRST	SECOND	THIRD	FOURTH	FIFTH	SIXTH	SEVENTH	EIGHTH	NINTH	TENTH	YEAR OF COURSE / MONTH OF COURSE
Orthography			E	E	E	E		E	E				
Reading			G	G	G	G		G	G				
Writing			G	G	G			G	G				
Number													
Arithmetic			G	E	7	G		G	E				
Language													
Grammar			G	G	G	G		G	G				
Geography			G	G	G	G		G	E				
Physiology			G	G	G	G		G	G				
History			E	E	E	E		E	E				
Civil Gov't													
Days of school			14	19	18	17	4	20	18				
Days absent			6	0	1	3	6	0	2				
Times tardy			4	7	6	7	4	10	18				
Deportment			G	G	G	G		G	G				

GRADE { Excellent, 95 to 100 Good, 85 to 95 Fair, 75 to 85 Unsatisfactory, 60 to 75 Poor, Below 60 Required Av. 75% Minimum 60%

105

Evanston High School fielded its first boys' basketball team in 1916. In 1919, the team won the state championship. Members of the first team, pictured here, are unfortunately unidentified.

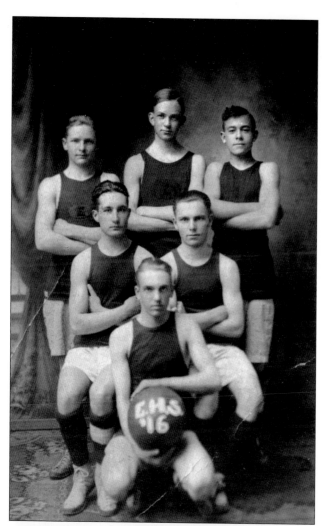

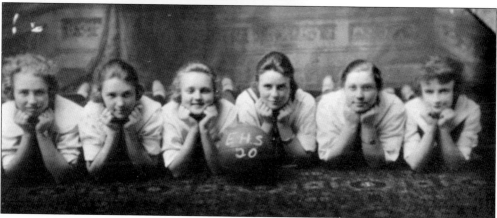

The Evanston High School girls' basketball team in 1920 consisted of, from left to right, LaFaun Christensen, Emma Hutschenreiter, Jacke Newton, Florence Anderson, Iva Taylor, and Dorothy Kehoe. The team lost just one game that season.

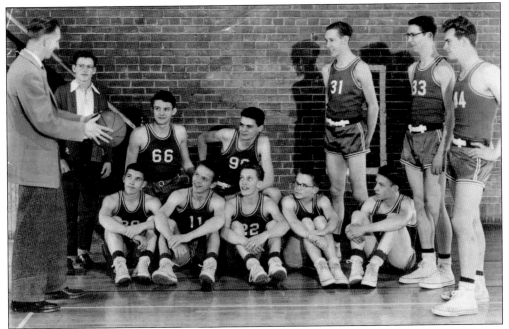

The 1950–1951 Evanston High School boys' basketball team listens carefully to coach Kay Petersen while manager Ellis Atkinson watches. Members of the team included, from left to right, (first row) Jack Robinson, Jim Rasmussen, Bill Stonebraker, Wally Piirainen, and Wayne Stevenson; (second row) Jim Redfield, Wallace Watts, Sonny Davidson, Paul Skyles, and Jean Cole.

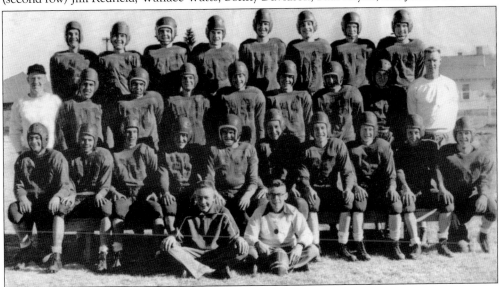

The 1951–1952 Evanston High School football team won the state championship. Members of the team included, from left to right, (first row) managers Harold McDonald and Shelly Horne; (second row) Russ Myers, Jim Parsons, Cliff Stuart, Bill Narramore, Jim Perkins, Bob King, Bill Stonebraker, Ken Houtz, Gary Verniew, and Jack Parkinson; (third row) Eddie Talboom, Eddie Frazier, Dee Thornhill, Don Fredricks, Tilt Peterson, Jim Rasmussen, Gene Walton, Bob Hall, and Keith Bloom; (fourth row) Sid Harris, Ron Cheese, Bill Gerrard, Jim Redfield, Paul Skyles, Harold Thomason, Bare Marshall, and Bruce Thompson. (Courtesy of Paul Skyles.)

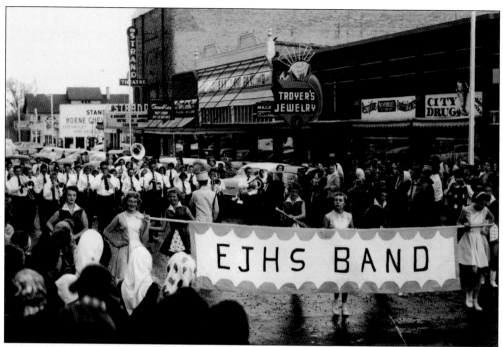

Evanston's homecoming parade in October was traditionally a big event in a town where nearly every resident was an alumnus. Here the Evanston Junior High School Band entertains the crowd on Main Street around 1950.

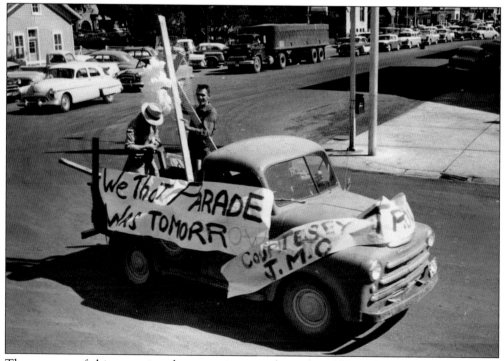

The creators of this entry in a homecoming parade in the 1950s poke good-natured fun at themselves and the event.

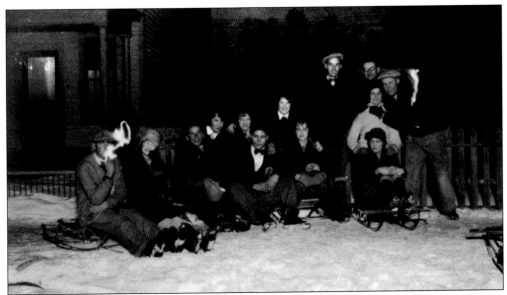

Residents of Evanston have always taken the opportunity to use their cold climate for fun. During the 1920s and 1930s, Twelfth Street between Center and Main Streets was closed to traffic in the winter so it could serve as a sledding hill. This group of young people in front of a house at the corner of Twelfth and Main Streets has clearly been enjoying a sledding party in the 1920s. The group included Rudger and Thelma Davis and Dave and Emma Maggard.

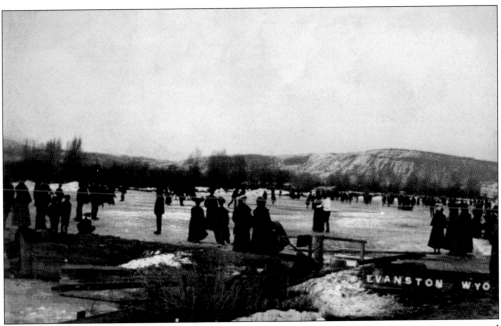

The ice ponds, created in the early 1900s, afforded a near-perfect ice-skating venue, as captured on this picture postcard from the 1910s.

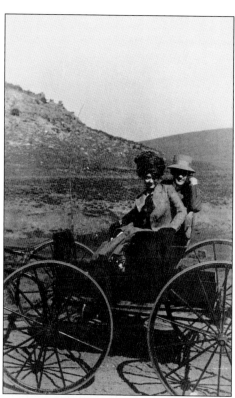

Summers in Evanston invite everyone to spend time outside. Here an anonymous couple enjoys a buggy ride.

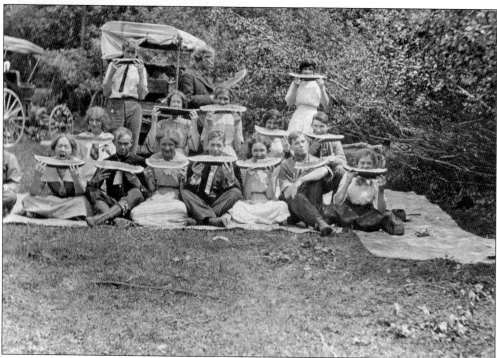

These picnickers have found a shady spot to enjoy the summertime treat of watermelon—and to record the moment.

Hunting has traditionally been a favorite pastime for Evanston residents. Here Alberto Eastman (center) and two unidentified companions enjoy a leisurely moment in their hunting camp.

Three unidentified hunters pose with their catch of sage grouse.

E. R. Casey was the superintendent of the Evanston Reclamation Plant for many years. From the late 1940s through the mid-1950s, Casey staged a special event every Christmas in the backyard of his home on Summit Street. With the help of Reclamation Plant workers, he created Santa's sleigh and reindeer and installed a mechanical Santa. Casey sat upstairs with a two-way radio in a room that overlooked the backyard and spoke to the children who came to see Santa.

Four

The World Comes to Evanston

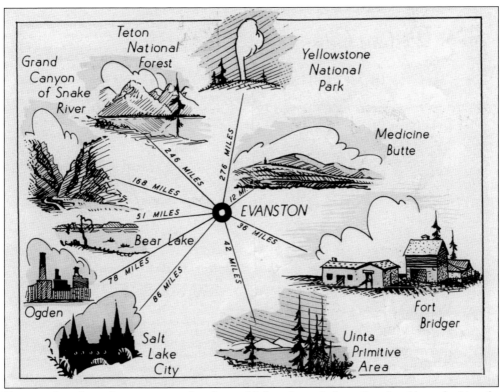

Evanston has always been connected to the world, first through the railroad and later the Lincoln Highway and Interstate 80. National and world events have had local impact, and Evanstonians have been drawn to other parts of the country and the globe over the years.

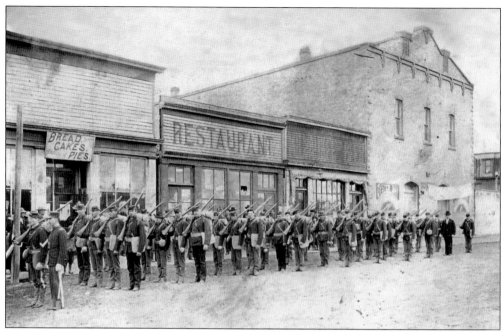

When the Spanish-American War broke out in 1898, Uinta County sent Company H (83 men) to the Philippines as part of the Wyoming 1st Infantry Volunteer Battalion, which was led by Frank M. Foote of Evanston. The company is shown here drilling on Front Street with the Downs Opera House behind them.

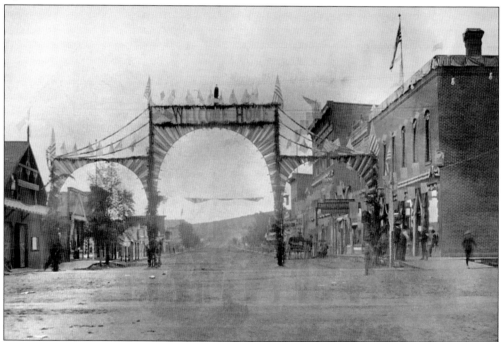

The Wyoming troops returned home from the Philippines by train from San Francisco in September 1899. Because Evanston was their first stop in Wyoming, the town planned a huge celebration in honor of the troops and built a triumphal arch across Main Street to welcome them.

Dr. Josiah Holland was a graduate of the George Washington University College of Medicine. He served in the Army Medical Corps during World War I and then returned to Evanston to open a medical practice. In addition to working as a physician, he served as mayor of Evanston, a trustee of the Uinta County Library, director of the Evanston National Bank, and member of the American Legion. As a physician, he delivered hundreds of babies; many older Evanston residents still identify themselves as "Doc Holland babies."

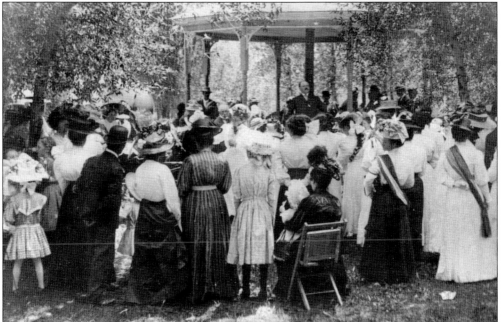

Evanston and Uinta County sent 450 soldiers to war in 1917. Fifteen were war casualties. In 1920, the citizens of the county dedicated a war memorial in front of the courthouse. It has since been expanded several times to accommodate the names of men and women who have served in subsequent conflicts.

In 1913, the Lincoln Highway—the nation's first coast-to-coast automobile route—was dedicated. The route of the Lincoln Highway through southern Wyoming brought it right through downtown Evanston. Evanston attorney Payson W. Spaulding was the first Evanston resident to own a car. He served as the Wyoming representative to the Lincoln Highway Association from 1913 until the association was dissolved in 1928.

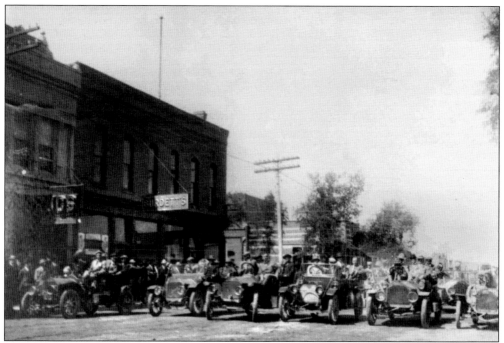

By 1911, there were more than a dozen cars in Evanston. Almost of them were assembled on Main Street for this photograph in that year. The picture is labeled, "All the cars in Evanston except Spaulding's."

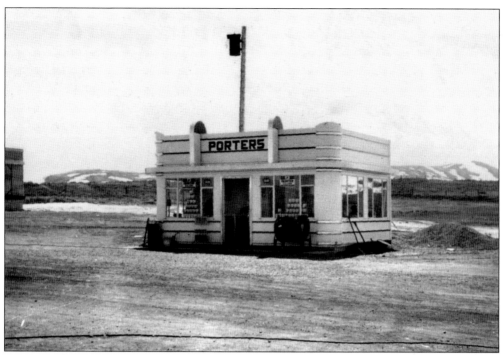

Accommodations for travelers quickly sprang up all along the Lincoln Highway. Porters Truck Stop on Eleventh Street west of downtown included a service station and the Frontier Café. This photograph dates to about 1951, after the Lincoln Highway had become U.S. 30. (Courtesy of Sandy Ottley.)

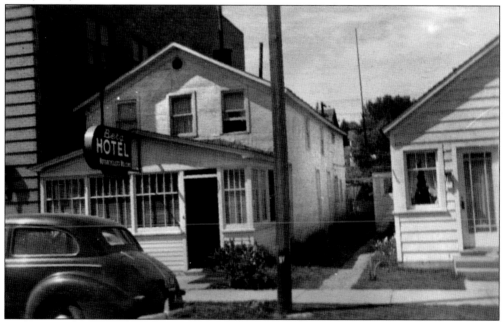

Several small hotels in town served Lincoln Highway and U.S. 30 travelers. The sign on the Berg Hotel near the corner of Main and Eleventh Streets announces that motorcyclists are welcome. (Courtesy of Sandy Ottley.)

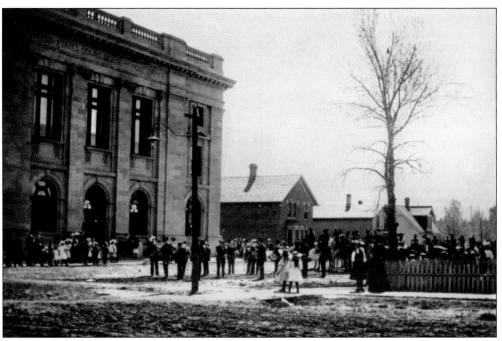

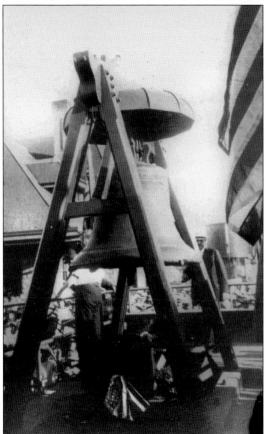

In 1908, the *Denver Post* sponsored the "Great Endurance Race," which challenged riders to cover 500 miles on a single mount. The race began in Evanston on May 30, cheered on by a large crowd of spectators. The winning horse and rider arrived in Denver seven days later. They were a bronco named Sam and Dock Wykert, both from Colorado.

In 1915, while war was raging in Europe, the Liberty Bell traveled by train from Philadelphia to San Francisco for the Panama-Pacific Exposition. Its route brought the bell through Evanston on Sunday, July 7. The train arrived at 7:00 a.m., but in spite of the early hour, hundreds of Evanston residents turned out at the depot to see the national treasure.

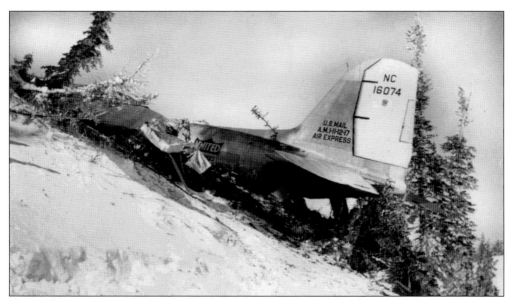

In October 1939, a United Airlines plane carrying passengers and mail crashed in the Uinta Mountains about 40 miles south of Evanston during a snowstorm. There were no survivors. Rescuers had to reach the crash site on foot.

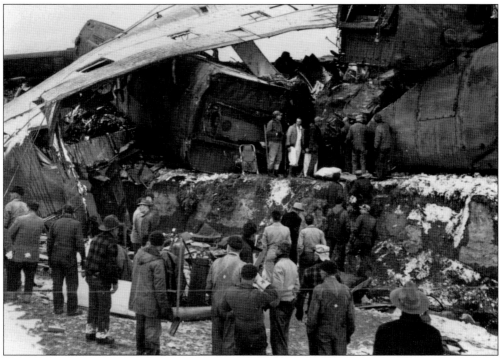

As a railroad town, Evanston was no stranger to accidents. One of the nation's worst train wrecks occurred just west of Evanston in November 1951 when the Union Pacific's *City of San Francisco* passenger streamliner hit the rear four cars of the *City of Los Angeles* streamliner. More than 20 people were killed in the wreck. Hundreds of Evanston residents turned out in a blizzard to assist the victims and clear the debris.

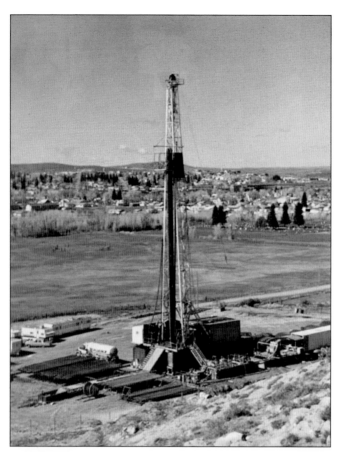

From the mid-1970s through the mid-1980s, an energy boom driven by oil and gas exploration brought the greatest changes Evanston had seen in its century-long history. From a population of 4,400 in 1975, the community swelled to between 12,000 and 15,000 by 1980. Much of the new population consisted of young, single construction and oil field workers. (Left, photograph by Michael McClure; below, courtesy of Jon Pentz.)

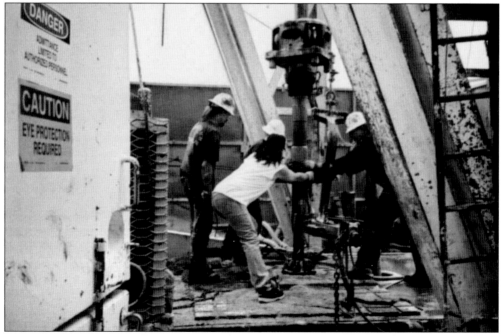

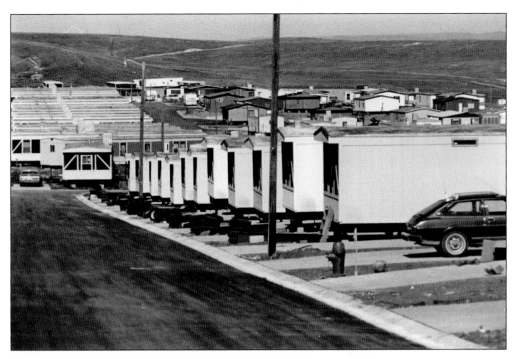

The boom put tremendous strain on housing, health care, municipal services, and social relations. The construction of new housing dramatically changed the configuration of the town as new subdivisions began to ring the downtown core and trailer parks sprang up to accommodate temporary workers. New businesses catered to well-paid young workers. The Whirl Inn on Eleventh Street was one such establishment. It was known locally as the "Whirl Inn and Stagger Out." (Above, courtesy of Michael McClure)

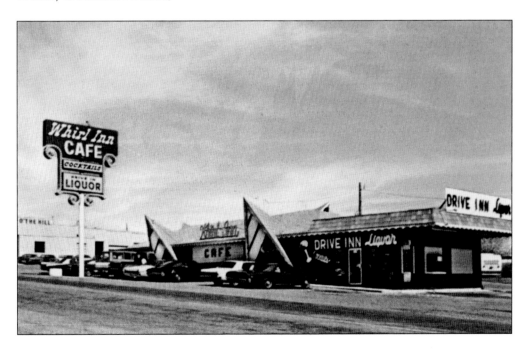

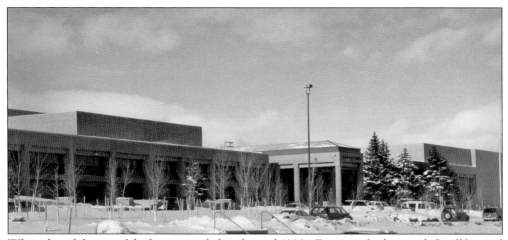

When the tidal wave of the boom receded in the mid-1980s, Evanston had expanded well beyond its original downtown and had gained six new school buildings (including the new high school pictured here), a new hospital, a human services facility, a recreation center, and a wastewater treatment plant. (Photograph by Kay Rossiter.)

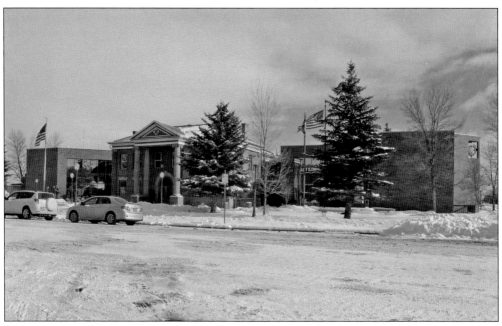

The expansion of the Uinta County Courthouse in 1984 encompassed the past, present, and future of the community as the new wings wrapped around and reflected the original structure. By 1985, the population level in Evanston settled down to about 10,000, with the number of nonnative residents nearly matching those whose families had been here for generations. (Photograph by Kay Rossiter.)

Five

PRIDE AND PRESERVATION

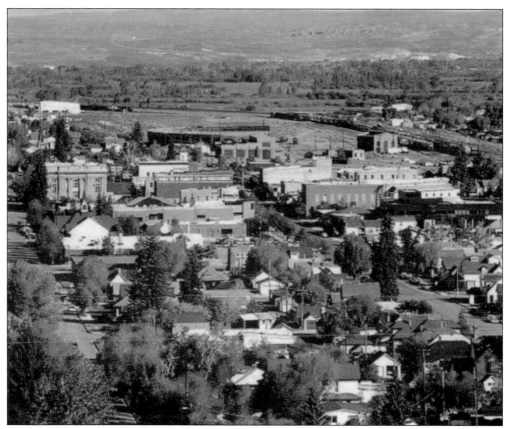

By 2000, Evanston's population had reached 12,000. Its economy and its people had survived the aftereffects of the boom, and the community had achieved regional and national attention for its historic preservation activities. (Photograph by Rick Lunsford.)

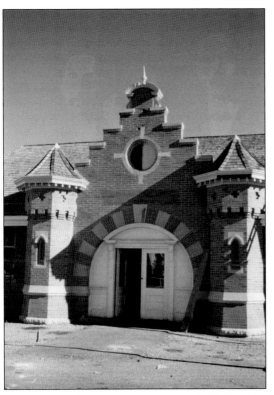

The rapid changes wrought by the boom raised alarms about the impact on the historic fabric of Evanston's downtown and prompted the first historic preservation efforts in the community. The first preservation project was the restoration of the Union Pacific passenger depot, deeded to the City of Evanston in 1985 after the railroad discontinued passenger service in southern Wyoming. Using large amounts of volunteer labor, grant funds, and the concept of adaptive reuse, the city refurbished the depot and transformed it into a community meeting place. (Courtesy of EURA.)

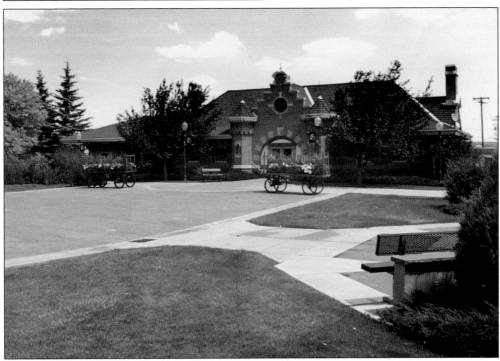

The restoration of the depot inspired the creation of Depot Square, a civic plaza encompassing the block of Front Street in front of the depot. (Photograph by Shane Wright.)

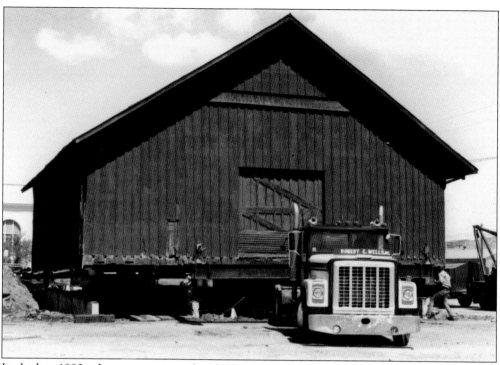

In the late 1980s, the city was given the old Beeman and Cashin implement barn that had stood for years along the tracks as a storage building. The city moved the barn into Depot Square and refurbished it as a community facility for public and private events. Despite initial community skepticism about the project, a large crowd turned out for the dedication of the building, which has been in constant use ever since. (Both, courtesy of EURA.)

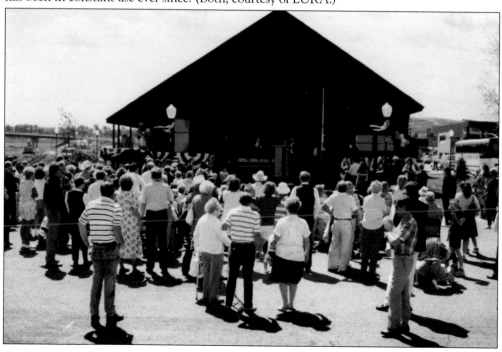

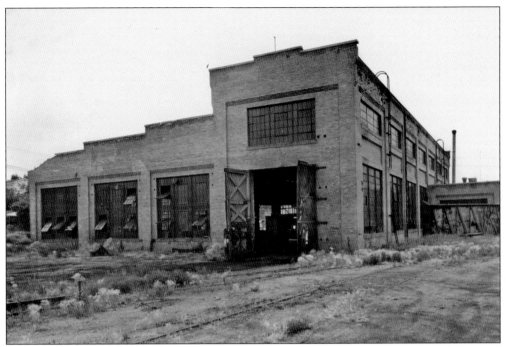

By far the largest historic preservation undertaking in Evanston has been the rehabilitation of the Union Pacific machine shop and roundhouse, which were deeded to the city by the railroad in 1972. (Photograph by Richard Collier; courtesy of EURA.)

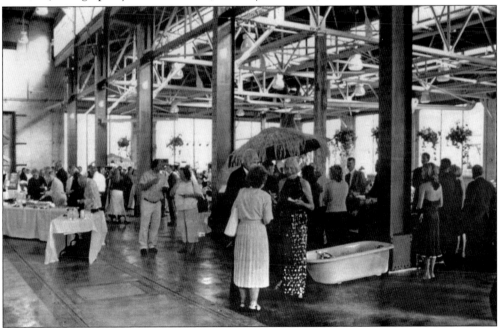

After years of neglect, the machine shop was fully rehabilitated between 1999 and 2003 and has now taken on new life as a community events center. Evanston's preservation efforts are supported by an annual fund-raising event, the Renewal Ball, which has raised more than $750,000 since 1982. Here attendees at the 2003 Renewal Ball enjoy the new facility. (Courtesy of EURA.)

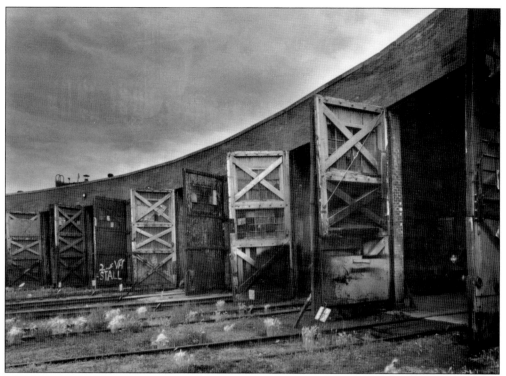

The massive 61,000-square-foot roundhouse, which saw so much activity during its 75 years of working life, had also suffered serious neglect in the 1980s and 1990s. (Photograph by Richard Collier; courtesy of EURA.)

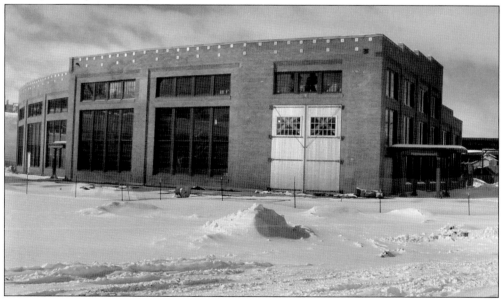

The roundhouse is the focus of current preservation and restoration efforts. Whatever the future use of the roundhouse may be, its distinctive red-brick arc will be a permanent reminder to residents and visitors alike of Evanston's pride in its history and commitment to its future. (Photograph by Kay Rossiter.)

ACROSS AMERICA, PEOPLE ARE DISCOVERING
SOMETHING WONDERFUL. THEIR HERITAGE.

Arcadia Publishing is the leading local history publisher in the United States.
With more than 5,000 titles in print and hundreds of new titles released every
year, Arcadia has extensive specialized experience chronicling the history of
communities and celebrating America's hidden stories, bringing to life the people,
places, and events from the past. To discover the history of other communities
across the nation, please visit:

www.arcadiapublishing.com

Customized search tools allow you to find regional history books about the town
where you grew up, the cities where your friends and family live, the town where
your parents met, or even that retirement spot you've been dreaming about.